WILDLIFE
LANDSCAPES
YOU CAN PAINT

NORTH LIGHT BOOKS
CINCINNATI, OHIO
www.artistsnetwork.com

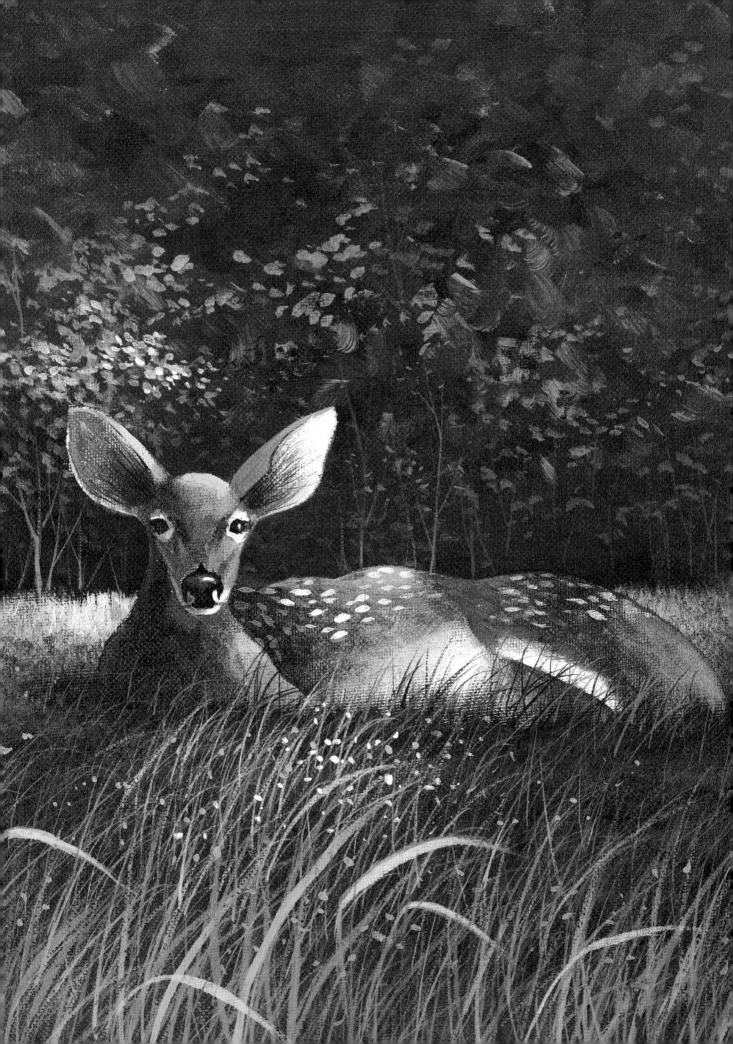

10 ACRYLIC PROJECTS USING JUST 5 COLORS

WILDLIFE
LANDSCAPES

YOU CAN PAINT

Wilson Bickford

METRIC CONVERSION CHART

To convert	to	multiply by
Inches	Centimeters	2.54
Centimeters	Inches	0.4
Feet	Centimeters	30.5
Centimeters	Feet	0.03
Yards	Meters	0.9
Meters	Yards	1.1

Other fine North Light Books are available from your local bookstore, art supply store. Visit our website at www.fwmedia.com.

13 12 11 10 09 5 4 3 2 1

DISTRIBUTED IN CANADA BY FRASER DIRECT
100 Armstrong Avenue
Georgetown, ON, Canada L7G 5S4
Tel: (905) 877-4411

DISTRIBUTED IN THE U.K. AND EUROPE BY DAVID & CHARLES
Brunel House, Newton Abbot, Devon, TQ12 4PU, England
Tel: (+44) 1626 323200, Fax: (+44) 1626 323319
Email: postmaster@davidandcharles.co.uk

DISTRIBUTED IN AUSTRALIA BY CAPRICORN LINK
P.O. Box 704, S. Windsor NSW, 2756 Australia
Tel: (02) 4577-3555

Library of Congress Cataloging in Publication Data
Bickford, Wilson.
 Wildlife landscapes you can paint : 10 acrylic projects using just 5 colors / Wilson Bickford.
 p. cm.
 Includes index.
 ISBN 978-1-60061-120-9 (pbk. : alk. paper)
 1. Nature (Aesthetics) 2. Acrylic painting--Technique. I. Title.
 ND1460.N38B53 2009
 751.4'26--dc22
 2008037462

Edited by Sarah Laichas
Cover design by Lauren Yusko
Design by Doug Mayfield
Production coordinated by Matt Wagner
Photographed by Christine Polomsky

ABOUT THE AUTHOR

From an early age, Wilson Bickford possessed a passion for art and animals that eventually led him to capture the wonders of nature on canvas. Though still life, florals and landscapes are common themes in his paintings, animal friends are his favorite subjects.

His work has earned many awards over the years, and his easygoing teaching style has brought him into contact with thousands of students from all walks of life. His firm belief that anyone can paint, and his dedication to sharing his knowledge and experience, is reflected in the demand for his classes.

Wilson has never met a medium he didn't like, and works in oils, acrylics, watercolors and pen and ink. In addition to teaching classes and workshops, Wilson records and produces instructional DVDs. They are available via his website, www.wilsonbickford.com.

ACKNOWLEDGMENTS

There are not enough pages in this book to thank all the individuals who have played major roles in my art career. Inspiration and encouragement are the two most important requirements any artist can hope to receive, and I have certainly been given more than my share.

My strongest influence in picking up a brush in the first place was the late William Alexander. Bill was the fore-runner of the television art show, and gave great inspiration to millions of viewers. When he said, "You can do it," I had no doubt that I could! More than thirty years after his first PBS television series, he still impacts aspiring artists through rebroadcasts and videos. His longevity speaks for itself.

As for encouragement, my wife Glenda and daughter Amy have always been there with advice, support and an honest critique when I needed one. They also roll up their sleeves to lend a hand with whatever needs to be done, whether it's maintaining my website, or helping out at a workshop. It's well known that what goes on behind the scenes is what makes for success, and that has never been more true than in my case. I will never be able to repay their efforts.

Also, I extend a sincere thank-you to the hundreds of students I have had the pleasure to meet during the past two decades. They are more friends than students, and we have truly become a family. They have made it possible for me to continue to do what I love most, painting, and no words will offset that debt.

I also thank the staff of North Light Books for allowing me to create this book. In particular, Pam Wissman, Barb Kraus and Sarah Laichas, for believing in me and helping me put it all together. This project would have never come to fruition without them.

Lastly, I owe a debt of gratitude to you, the reader, for acquiring and reading my book. I hope you find it enjoyable and I hope my techniques are easy to incorporate into your own artwork.

I believe you can do it, but you must believe in yourself!

DEDICATION

I dedicate this book to aspiring and established artists everywhere. I believe that every person has a creative side, but too few of us get the opportunity to explore that part of our personality.

Here's hoping that you ultimately find the chance to tap into your artistic potential and allow it to enrich your life.

Table of Contents

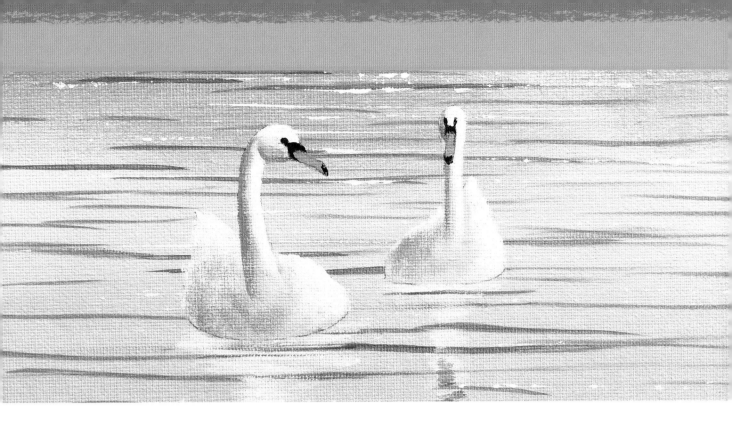

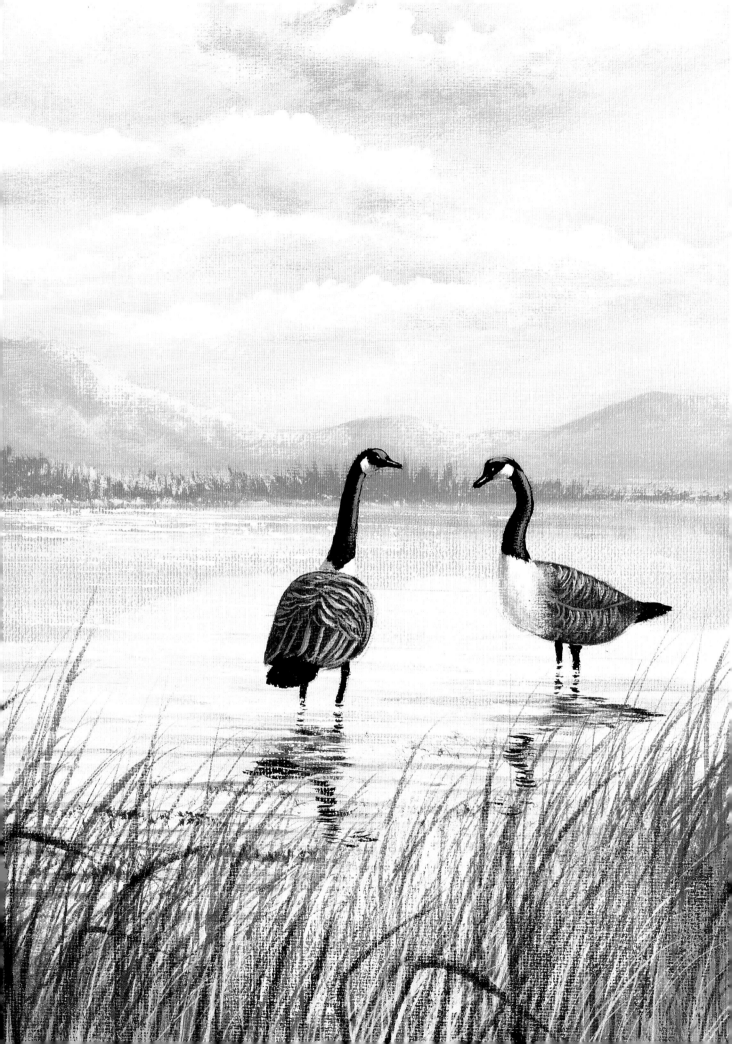

Introduction

Welcome, and thank you for your interest in this, my first book. I've been a full-time artist and instructor for many years now, and one thing I have learned in my years of teaching is that people are people no matter where I go. Therefore, I think I can draw a few conclusions about you. Obviously, you are interested in improving your painting skills. But, more than that, I'll bet that you love nature and life's simpler things. You enjoy working with your hands and take pride in doing so. The idea of creating something of beauty truly appeals to you. You are optimistic, compassionate for others and determined in whatever you do.

Am I getting close? Maybe just a little bit? This profile describes about 90 percent (or more) of the hundreds of students, friends and curiosity-seekers I have met in my nearly twenty years of conducting art classes and workshops.

I have been fortunate to meet so many wonderful people through my art. Painting has brought us together, just as it is now bringing you and me together.

We artists see things in a different way than other folks. Everyday things that are seen as common or mundane by other people take on a new life to the artist. We can see beauty in most everything and we appreciate the little things. Colors take on new meanings.

The most common remark I hear from beginning students is, "I never noticed clouds and trees before, but I can't stop looking at them now. I just never noticed how beautiful nature really is."

That feeling of awe, wonderment, inspiration, whatever you wish to call it, never goes away. Once you experience it, it's with you for life, whether or not you pursue painting.

That aspect alone is reason to pick up a brush. Getting in tune with and appreciating nature is never a bad thing. I am pleased to be able to offer projects depicting animals, not just because they are fascinating subject matter, but because I am a true animal lover.

If you are a beginning painter, don't be too hard on yourself with your first paintings. The old adage, "Practice makes perfect," definitely applies to painting. You will learn far more from your mistakes than any other way. Believe in yourself because you can do it! We all have fear of the unknown, and if painting is a new endeavor for you, it can be intimidating and challenging. But, it will also be fulfilling, rewarding and fun.

So, let's get started. Pick a project and go for it! You're on your way to ten wildlife landscapes you can paint!

Canada Geese at the Shore
Acrylic on canvas panel board
16" × 12" (41cm × 30cm)

I have designed ten landscape projects that require minimal tools and paints. It's easy to become confused by the array of brushes available to today's artist—simpler is always better when you're just starting out.

Like anything in high supply, some brushes are poorly made and some are expensive, so it pays to shop around. I find that the Princeton Art & Brush Company offers an exceptional product at a fair price. Choose brushes that strike a balance between quality and cost.

Here are the six brushes and tools you'll need:

6 BRUSHES AND TOOLS

1½-inch (38mm) flat wash brush
This soft, paddle-style brush is made of synthetic bristle and is used for putting in backgrounds because it holds a lot of moisture and pigment.

A wash brush is capable of creating a razor-thin edge when wet, but is also useful for adding texture for grasses, leaves and other foliage when it's less damp.

No. 10 bright brush (synthetic)
No. 2 round brush (synthetic)
These brushes are made from stiff, synthetic bristle ideal for acrylics. They have a similar feel to the white hog-bristle brushes used by oil painters, but with a softer touch. Look for brushes that specify use for acrylics.

No. 3 fan brush (white hog-bristle)
This brush is thought of more as an oil-painting brush, but I have found that the coarseness of the bristle works well for rendering grass and foliage in acrylic. It's also great for fluffing in cloud shapes.

No. 2 script liner brush
This thin, long-haired brush is used for creating fine lines, such as grass and tree branches, and detail. Any of the synthetic varieties, such as Taklon, work well, but sable is the ideal choice.

Small painting knife
This traditional, trowel-shaped tool with an offset handle is perfect for creating water sparkles, tree bark and other rough textures. Size designations vary greatly, but choose one with a blade length of 1¼ inch to 1½ inch (3cm to 4cm) from tip to heel. See page 39 for instructions on creating water sparkles.

PAINTS

To create the ten projects, you will need the primary colors—red, yellow and blue—as well as Burnt Sienna for dulling and darkening,

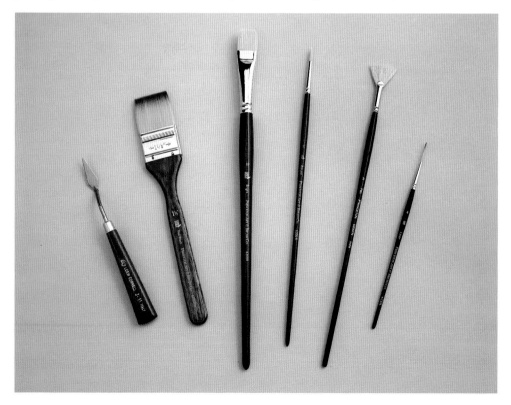

Brushes and Tools
You will need six brushes and tools for the demonstrations in this book. From left to right: a small painting knife, a flat wash brush, a no. 10 bright, a no. 2 round, a no. 3 fan brush and a script liner.

Miscellaneous Tools

In addition to five paint colors, some other tools you will need are a moisture-retaining palette, white gesso, a spray bottle and a water container.

and Titanium White for lightening. From the three primary colors, you can mix the secondary colors green, orange and violet.

Here are the pigments you'll need:

Ultramarine Blue
Cadmium Red
Cadmium Yellow Pale
Burnt Sienna
Titanium White

ACRYLIC WHITE GESSO

We will use this medium as the basetone for establishing the large background areas. It comes in jars or bottles and is made by many different manufacturers. I prefer the jarred varieties because they tend to have more body. Bottled gesso works fine, too. It's up to you to decide which you prefer.

WATER CONTAINER

Nothing fancy is required—an old bowl or coffee can will work fine!

PALETTE

You will need a suitable surface for laying out and mixing your paints. I use a large Masterson Sta-Wet Palette, made especially for acrylics and water-based paints, which keeps pigments moist.

The palette is simple to set up and comes with detailed instructions. A damp cellulose sponge underlays a special sheet of acrylic paper that holds the paint. When the lid is closed, the paints stay in workable condition for days.

In lieu of the Sta-Wet Palette, any nonabsorbent surface will suffice. A sheet of heavy wax paper, a disposable foam or paper plate, or even a sheet of glass will work.

The wax paper can be tossed after use and the glass can be scraped clean with a razor blade. However, you will need to keep your paints moist and workable by frequently spritzing them with a spray bottle of water.

SPRAY BOTTLE (MISTER)

This is a handy, almost essential tool to have at your disposal when painting with acrylics. It can be used to lightly dampen the canvas to extend the drying time, and for moistening your paints on the palette.

It is very important to use a bottle that dispenses a fine mist, not big droplets of water. This is also a favorite tool of watercolorists, and can be found at most art supply and craft stores.

Other Materials

GRAPHITE TRANSFER PAPER

Use this treated black paper to transfer the animal sketches to canvas after the background of the painting is completed and dry. I recommend using an erasable type available at most craft stores, so you can easily remove unwanted lines. (Learn how to transfer your drawings on page 15.)

CANVAS

Each project is completed on a 12" × 16" (30cm × 41cm) panel canvas. However, you can use a stretched canvas as well. Most of the canvas products you'll encounter at your local art supply store will be pre-primed and ready for paint. Just make sure they are double- or triple-primed—inadequately primed surfaces will soak in the paint, making blending difficult.

VARNISH

Adding a final varnish to your painting will protect it from the elements and abrasion. While many artists feel this is unnecessary with acrylics, I prefer the uniform, finished-look that it imparts. Whether you choose a gloss or matte finish, the application procedure is the same.

Varnishes come in aerosol spray cans or jar form, which is applied with a large brush, such as the 1½-inch (38mm) wash brush.

It is most important to strive for an evenly distributed, uniform application across the entire canvas. An uneven varnish layer will yield shiny spots where the sealant is slightly heavier and dull spots where it has been applied sparingly.

I prefer the brush method because it gives me more control. Using the spray method can result in runs and drips if you're not careful. Try both ways to see which one you like.

If you're hesitant to try varnishing a finished painting, practice on a blank canvas. You can still paint the canvas later.

BRUSH CARE

During your painting session, keep your idle brushes wet to prevent paint from drying in the bristles. Dry acrylic will ruin a good brush!

When you finish a painting session, thoroughly wash your brushes in soap and water. You can purchase commercial brush soaps and cleaners that contain conditioners to protect the bristles, but really, any soap will suffice and will be better than no soap at all.

Carefully scrub the soapy bristles in the palm of your hand and rinse them under running water. Repeat this step until the brush rinses completely clear.

Dry the brushes on paper towels and store them flat, or upright (handles down) in a jar or similar container.

Miscellaneous Supplies
A few more important supplies: graphite paper, varnish to seal your paintings, a red ballpoint pen, a pencil and paper towels.

Working With Acrylics

Acrylics are a wonderful medium for beginners because they are versatile, quick-drying and affordable. Here are some tips, tricks and words of wisdom to help you get started with acrylic paints and backgrounds.

About Acrylics

Acrylic paints are the bridge between oils and watercolors. They are blendable like oils, but dry much faster—in mere minutes rather than days or even weeks.

Acrylics are water-based like watercolors, but permanent and insoluble when dry. They dry by evaporation and can also be dried very quickly with a hair dryer.

If thinned with a sufficient amount of water, acrylics can be used in a fluid approach just like watercolors.

We will practice handling acrylics like oils. Acrylic paints dry slightly darker than they look when wet. To account for this, simply create your mixtures a touch lighter than you wish them to be in the end result. As you gain experience, you will become skilled at mixing colors to your liking, then tweaking them to create subtle shifts in value (see pages 18–21 to learn more about the basics of color, values and mixing).

Modifying Your Paints

There are many mediums available for modifying acrylic paints. Additives to thin the consistency, retarders to slow the drying time, gels to thicken the paint—you name it, it's out there.

I rarely modify my paints because I prefer a thick consistency. I typically thin my paints with a little water to improve their flow just enough to retain their adhesive quality. Watering down the paint too much can result in poor bonding of the paint layers.

If you find that your style promotes a fair amount of paint thinning, you may wish to consider a thinning medium. When selecting paints, be sure to read the labels to understand each one's specific purpose.

Wet-Into-Wet Backgrounds

Each project in part two has a blended background, whether sky, water or both. Because of the fast-drying nature of acrylics, it is important to work quickly in the background area to achieve a smooth appearance.

The background area must be established first. Each background will be achieved in the same manner. The colors will vary from project to project, but the techniques employed will be consistent. Follow these steps when applying and blending these areas:

1 Lightly spray the canvas with the spray bottle, being careful not to saturate the canvas. A light degree of dampness is all that's needed. Spritzing will ease the paint application and help to extend the drying time. Remember, slightly damp, not soaked and dripping! If you do get too much water on the canvas, simply blot off the excess with a paper towel.

2 Immediately load the wash brush with a good amount of white gesso on the ends of the bristles. Cover the background area with an even coat using broad, back and forth strokes. Strive for an even distribution that's not too heavy. When the gesso is applied you will have approximately five minutes to establish your background colors before the paint starts to set.

Some of these projects require a blended background that covers the entire canvas, while other projects require only a partial area of coverage. This will be specified in the initial steps of the project.

3 Wipe any excess gesso from the wash brush and pick up a bit of background color. Don't clean the brush with water, just work quickly to blend the background color into the gesso on the canvas. Start applying the paint using swift, crisscross strokes (creating X shapes over and over) working across the top of the canvas and downward.

To smooth the blended area, wipe the brush on a towel to remove the excess paint, and use broad, back and forth strokes, sweeping across the whole width of canvas. Use a light touch when softening the blend of gesso and the background color. The goal is to remove, or at least to soften, any residual brush marks and texture.

With plenty of practice and experimentation you will improve your paint application, speed and blending skills.

Reference Photos

Reference photos are invaluable for analyzing the details, structure and anatomy of your subjects. This is true whether you're painting animals, florals or a still life.

I am constantly collecting photos, which I keep in a reference file, in the event that I want to paint a particular subject. My file includes not only photos I have taken, but also images from magazines, newspapers and calendars. These pictures are for reference only, not to blatantly copy, because they are protected under copyright by the photographer or publishing company.

You don't need an expensive camera to take your own photos, just one with a zoom feature. Usually, you can only get so close to a deer or goose without it shying away.

You will rarely snap a photo that is exactly what you want and is compositionally acceptable. I strive for a good photo of the animal subject, then rely on other photos or my imagination to construct the background and surroundings. It is perfectly acceptable to remove, edit and change the elements in a given photo to achieve a more pleasing arrangement for a painting.

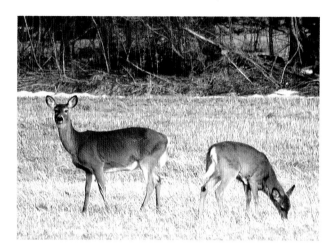

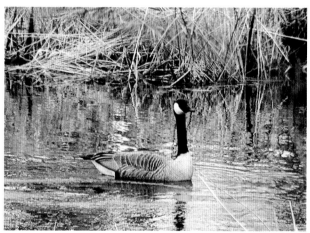

Reference Photos
Here are some photos taken by my wife, Glenda. Since we have a lot of wildlife in our area, photo opportunities like these are possible on a daily basis. These particular shots were all taken within a five-mile (8km) radius of our home during a one-hour evening drive.

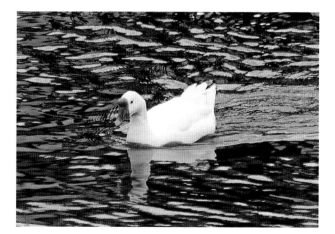

Don't Forget the Camera!
It's a good idea to keep your camera with you when you're on the road because you never know what you may encounter. I have missed out on many great photo opportunities by leaving my camera at home. Lesson learned!

Transferring Sketches

Each project is accompanied by an animal sketch shown in actual size. The actual-size sketches are the basis for the 12" × 16" (30cm × 41cm) canvases that I used throughout the book. You can reduce or enlarge the templates on a photocopier if you prefer to work with a different size.

Whether you use the animal designs provided or your own creations, I suggest creating a copy or two of each so you can preserve the drawings for later paintings.

Use a fine-point red ink pen to trace the animal. The color contrast of the pen against your drawing's outline will help you track your progress.

Be aware that if the background is particularly dark, the dark transfer paper may not leave a visible image. White transfer paper is also available at most art stores and would be the better choice in this instance.

When you are ready to transfer a sketch, the canvas *must* be absolutely dry.

Be careful not to apply pressure to or rub the heel of your hand on the graphite paper while tracing the image. This can result in smudges on the canvas. It's best to use erasable graphite transfer paper for this reason.

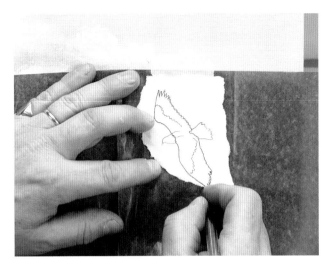

1 Cut around the drawing you want to trace, then tape the drawing and graphite paper to the dry canvas laid flat. You can secure the sketch with a piece of masking tape, but this is not necessary.

Using a fine-point red pen, gently trace the lines of the drawing to transfer the graphite. Be careful not to smudge any extra graphite with your hands. Use erasable graphite paper so you can erase any mistakes.

2 Behold the transferred drawing. The graphite is transferred only where you traced over it with your pen.

Animal Sketch Gallery

Sketching is a great way to sharpen your drawing skills. A small sketchbook is a handy accessory that will permit you to hone your skills virtually anywhere and at any time. On the bus, at the dentist's office, during your lunch break—anywhere! Get one that is compact enough to fit in your pocket or purse. Also carry a pen or pencil. Grade H (hard lead) pencils are good for light lines and the darker grade B (soft lead) pencils work well for shading.

Try sketching simple subjects at first, such as trees and rocks. Eventually work up to the old barn down the road or the front of the local café. Obviously, wild animals will not stop and pose for you, so photos are best for capturing them. But what about that bear or lion dozing the afternoon away at your local zoo? Get there and start sketching before he wakes up!

Do not confuse sketching with finished drawings. My pen-and-ink renderings shown here are more or less completed artworks. Sketches are best used for reference and recording details. As your drawing ability improves, it will be easier to tighten your loose sketches into finished drawings.

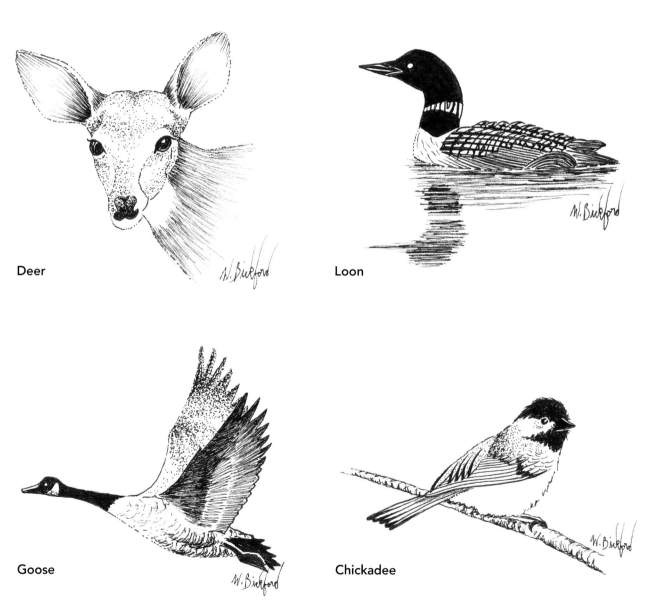

Deer

Loon

Goose

Chickadee

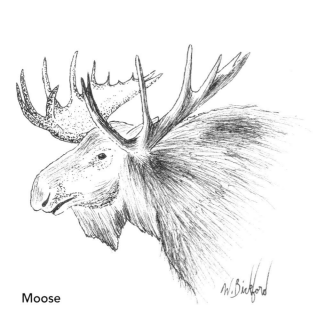

Moose

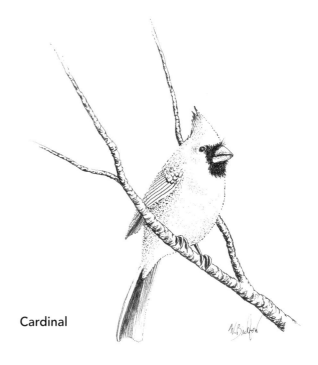

Cardinal

Butterfly

Raccoon

The Basics of Color

In my opinion, color is the true joy of painting. Infinite shades and tints (or dark and light versions) of every hue can be obtained by mixing. Most of my students tell me that mixing color to achieve a desired color is far more demanding than any brushwork. The best advice I have for you is to experiment and study the relationships of the color wheel.

Primary and Secondary Colors

In painting, these are the three main pigments—red, blue and yellow. The three secondary pigments—orange, green and violet—are created by mixing the three primary colors. The color wheel is the standard way to display the colors and how they relate to each other.

Complementary Colors

The best method for mixing hues is to use *complementary colors*. Simply put, any primary or secondary color can be dulled by adding a small amount of its opposite color on the color wheel. These combinations work conversely with each other. You will find that a small amount of a color's complement will make a big difference, so add just a touch of it until you achieve the desired shade. White can always be used to lighten a value. See pages 20–21 for more information on common color mixtures.

Value

In terms of color, *value* simply means how light or dark a color is. Every painting should have a broad range of values from very dark to very light, with all the nuances in between. Without enough contrast in values, your painting will lack depth and appear flat.

Generally speaking, darker values are achieved by using a stronger

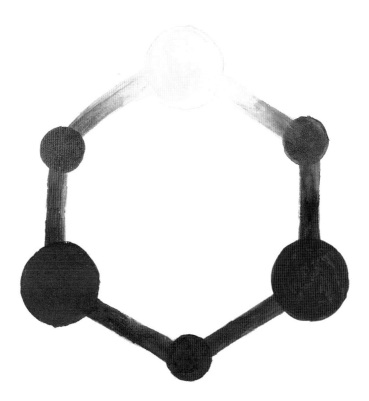

The Color Wheel
You don't have to memorize the entire spectrum of the color wheel, but memorizing the three main combinations will solve most of your color mixing challenges: red and green; yellow and violet; and blue and orange.

concentration of pigments, while lighter values are achieved by adding white (and sometimes lighter colors such as yellow).

As this theory applies to the ten projects, the distant objects and background elements appear lighter in value while the foreground and animal subjects appear darker. This is known as *aerial perspective*—creating a feeling of distance and spatial depth on the otherwise flat canvas surface.

Viewing your paintings from a distance or through squinted eyes will eliminate the details and make the value contrasts more discernible. It's a great way to judge your overall values. Remember, strive for strong lights, strong darks and everything in between.

SHADE AND TINT

Innumerable shades and tints of gray can be created by varying the pigment ratio of black to white. A *shade* is what you get when you add black, and a *tint* is what you get when you add white. A useful tip to remember is that it takes approximately equal amounts of Ultramarine Blue and Burnt Sienna to create a near-black mixture.

TEMPERATURE

Color temperature is helpful to consider in determining the mood of your paintings. Warm colors such as reds and yellows appear to come forward, and are used to convey warmer themes, such as sunsets. Cool colors, such as blue and greens, tend to recede and are especially good for portraying cold, wintry themes.

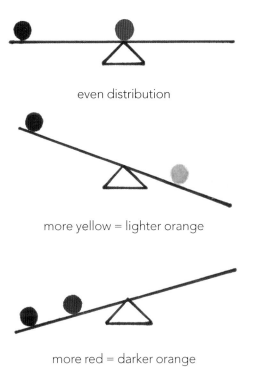

even distribution

more yellow = lighter orange

more red = darker orange

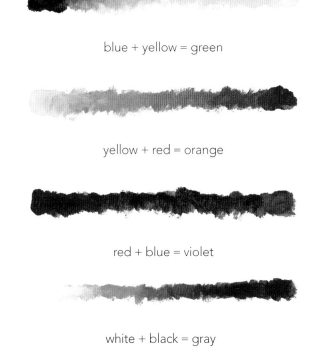

blue + yellow = green

yellow + red = orange

red + blue = violet

white + black = gray

Color Ratios

When you mix two primary colors to yield a secondary color, the secondary color is influenced by their ratio. Think of the relationship between the colors as a teeter-totter: the heavier hue always prevails. If the red is dominant, the resulting orange will be reddish in hue and also somewhat darker. If the yellow outweighs the red, the orange will be more yellowish in tone and generally lighter in value.

Value Scales

Check out the relationship between the black, white and primary colors. An infinite range of grays can be mixed with black and white. Placing strong values of opposite colors next to each other in a painting creates great contrast and adds visual excitement.

Common Color Mixtures

Since we will use only primary colors and Burnt Sienna, each secondary color will be acquired by mixing two primaries together. The secondary colors are influenced by the strength of their two components. In other words, the dominant primary color in the mixture will "flavor" the color accordingly.

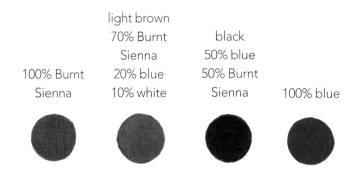

| 100% Burnt Sienna | light brown 70% Burnt Sienna 20% blue 10% white | black 50% blue 50% Burnt Sienna | 100% blue |

Creating Brown and Black

These mixtures will yield brown, black and gray (add white to the black mixture to create gray). Although the tones won't be true black or true brown, the mixtures will appear that way,

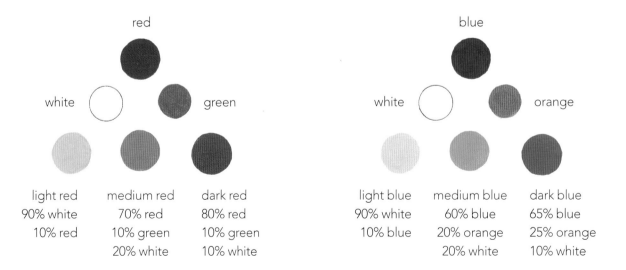

| light red 90% white 10% red | medium red 70% red 10% green 20% white | dark red 80% red 10% green 10% white |

| light blue 90% white 10% blue | medium blue 60% blue 20% orange 20% white | dark blue 65% blue 25% orange 10% white |

Varied Red Mixtures

Green and white combine with red to create light-, medium- and dark-red mixtures. Red and green are complementary colors.

Varied Blue Mixtures

Orange and white combine with blue to create light-, medium- and dark-blue mixtures. Blue and orange are complementary colors.

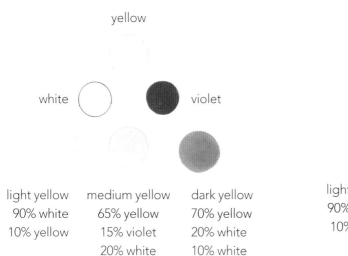

light yellow	medium yellow	dark yellow
90% white	65% yellow	70% yellow
10% yellow	15% violet	20% white
	20% white	10% white

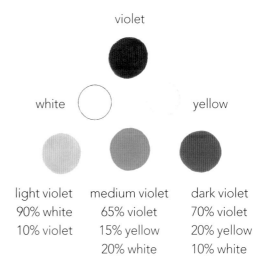

light green	medium green	dark green
90% green	65% green	70% green
10% white	15% red	20% red
	20% white	10% white

Varied Yellow Mixtures

Violet and white combine with yellow to create light-, medium- and dark-yellow mixtures. Violet and yellow are complementary colors.

Creating Green

Use the primary colors blue and yellow to create green. More blue or yellow will tint the mixtures accordingly. White and red, green's complement, are used to create light-, medium- and dark-green mixtures.

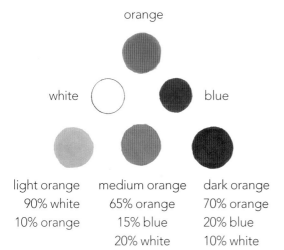

light orange	medium orange	dark orange
90% white	65% orange	70% orange
10% orange	15% blue	20% blue
	20% white	10% white

light violet	medium violet	dark violet
90% white	65% violet	70% violet
10% violet	15% yellow	20% yellow
	20% white	10% white

Creating Orange

Use the primary colors yellow and red to create orange. More yellow or red will tint the mixtures accordingly. White and blue, orange's complement, are used to create light-, medium- and dark-orange mixtures.

Creating Violet

Use the primary colors red and blue to create violet. More red or blue will tint the mixtures accordingly. White and yellow, violet's complement, are used to create light-, medium- and dark-violet mixtures.

Brush Techniques

Before you begin painting, study the techniques and terminology used throughout the ten projects. Refer to this section when you need a visual of how to load the brush with paint or place the bristles on the canvas.

No. 10 Bright Brush

Straight, Fine Lines
Load the brush with paint to a chiseled point. Holding it vertically, pull the brush down the canvas to create straight, thin lines. Use this technique to begin a tree trunk. (See steps 3 and 5 of *Downy Woodpecker*, pages 119, 121.)

Wave Lines
Load the brush with paint to a chiseled point. Hold the brush loosely and pull horizontally to create thin wave lines in calm water. (See *Trolling the Shore* on page 60.)

Rough Foliage
Dab the pointed corner of a no. 10 bright to suggest rough foliage.

No. 2 Script Liner

Very Fine Lines
Load the liner to a fine point to gently create thin, lined details such as animal eyes, beaks and tree branches. (See step 14 of *Marsh Landing*, page 94.)

No. 3 Fan Brush

Vertical Chiseled Edge
Load the bristles with paint and work them into a flat point. Tap the top of the bristles vertically to render distant evergreens. (See step 3 of *Mom and Cub*, page 47; and step 3 of *Marsh Landing*, page 87.)

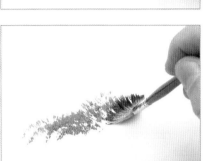

Horizontal Chiseled Edge
Load the bristles with paint and work them into a flat point. Tap the flat side of the brush horizontally on the canvas to achieve fine grass texture. (See step 4 of *Swan Duet*, page 109.)

Spiky Bristles
Load the bristles with paint and work them into a flat point. The bristles will form spiky clumps. Tap the corner of the brush against the canvas to create rough, distant foliage. (See the "Group of Deciduous Trees" exercise on page 57.)

1½-inch (38mm) Flat Wash Brush

Background Trees or Large Grass Areas
Load the end of the brush with paint and press it against the palette to create spiky clumps of bristles. Dab the ends of the bristles horizontally along the canvas to render large areas of rough grass and bush (see *Mom and Cub*, page 49) or distant banks against water's edge (see *Loons on the Lake*, page 81).

No. 2 Round Brush

Blocking Large, Detailed Areas
Roll the brush tip in paint, covering the length of the bristles. Block in large, detailed areas with this stroke, such as the body color of the bears in step 8 on page 50.

Distant Bushes
Load your brush as you would to block in large, detailed areas. Tap the loaded brush tip against the canvas to achieve rough, controlled detail, such as the red bushes on the shore of step 14 on page 64.

Winter Doe

Whitetail deer are prevalent where I live in the northeast U.S., and I see them in distant fields and meadows almost every day as I drive along the country roads. The most visible deer are does and fawn. Bucks are reclusive and sightings of them are rare.

Whitetails are a rusty orange color during the spring and summer months, then turn a brownish gray during the winter. I love to paint them and I think you will, too!

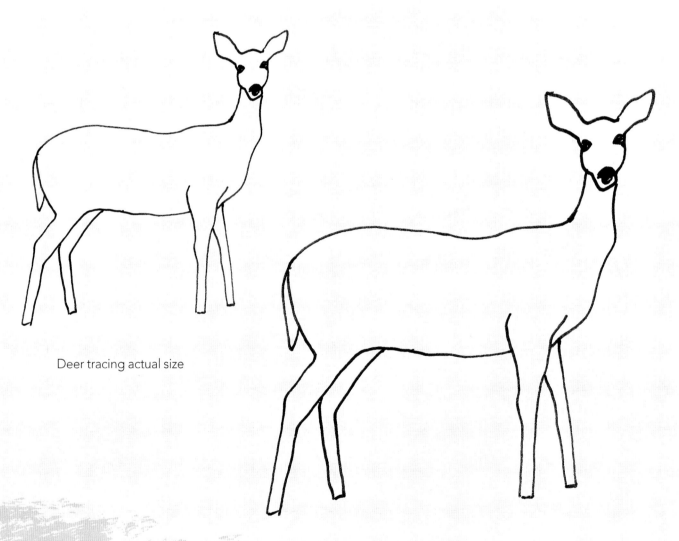

Deer tracing actual size

Deer tracing enlarged size

Materials
Refer to pages 10–12 for a list of the paints, brushes and tools you will need for each of the ten projects.

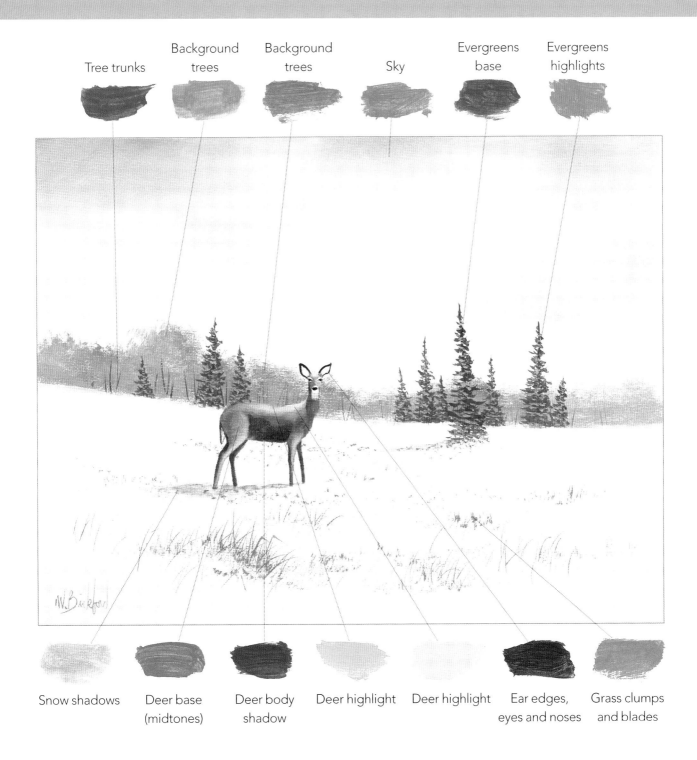

Tree trunks

Background trees

Background trees

Sky

Evergreens base

Evergreens highlights

Snow shadows

Deer base (midtones)

Deer body shadow

Deer highlight

Deer highlight

Ear edges, eyes and noses

Grass clumps and blades

COLOR MIXTURES

Sky; background trees; evergreens (basetone and highlight); tree trunks; snow shadows; grass clumps and blades; deer base color (midtone); deer body shadow; deer highlight; ear edges, eyes and nose

1 Begin the Sky

Sketch the horizon line with your pencil. Note that it slopes slightly downward and to the right, and is not just a straight line. Dampen the sky area with the mister bottle and apply a uniform coat of gesso to this area with the wash brush. With a touch of blue and a touch of sienna, create a grayish blue mixture on your palette to give the sky a cold, wintry feel. Work this mixture into the sky with a gentle and random back and forth motion. The white areas you create should suggest cloud movement. Quickly wipe the brush on a damp paper towel and use light crisscross stokes (like an X-shape) to minimize any coarse brush marks.

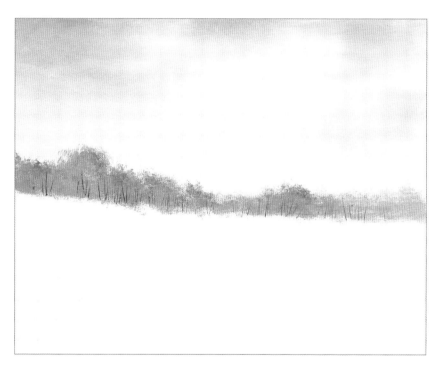

2 Render the Distant Treeline

While the sky is wet, mix the distant treeline color with white, sienna and a touch of blue. Load the mixture on the corner of the fan brush and dab the bristles in a circular motion just above the horizon (see the "Spiky Bristles" brush technique on page 23). Use light pressure to yield a soft edge along the top of the tree branches and to place distance between the foreground and background. Add a touch more sienna to the fan brush and randomly tap in a darker value across the base of the treeline to break up the solid color and add variety.

Darken the treeline color with a touch more blue and a speck more sienna and gently brush in the indication of a few tree trunks with the script liner brush. Always thin the paint with water when using the liner brush to allow for more precise brushstrokes. Softly pull the bristles from bottom to top to give the trunks a natural taper.

Using the Script Liner Brush

When painting distant tree trunks, keep your wrist loose to achieve a slight to-and-fro sway with your brushstrokes. You don't have to be too nitpicky with the details of the limbs because they are so far off in the background.

Simple Pine Tree

EXERCISE

Pine trees are abundant throughout nature and are the perfect object to include in your animal landscapes. You will paint a lot of them in the projects to come, so practicing this simple exercise now will improve your conifer skills and confidence!

MATERIALS LIST

BRUSH
Script liner

COLORS
Burnt Sienna, Cadmium Yellow Pale, Titanium White, Ultramarine Blue

1 Add blue or yellow to the distant tree color from step 2 on page 26 (it's made from even amounts of sienna and white, and a touch of blue).

Mixing more yellow will give you a bright yellowish green, and more blue will yield a muted bluish green. There's no right or wrong; the color mixture is up to you. To create the conifers, thin the green value with water. Using the liner brush, start at the top of the tree and pull a thin line down toward the base of the trunk. With a dabbing movement work your way down the tree, widening your strokes as you go.

2 Tap in the smaller branches from the center of trunk outward, to the left and right. To leave some breathing space between the branches, don't paint a solid color. Keep dabbing the liner into water to ease the flow of paint from the brush. Remember, a natural-looking tree looks like the wind could blow through it.

3 When your tree is full of branches and dry, mix the highlight color by adding a touch of white to the green basetone. Highlight the tree branches down the middle. Since there is no distinct light source, the highlights fall in the center. Highlight the left or right of the branches, depending on where the light source is coming from in your landscape.

3 Place the Foreground Pine Trees

Follow the "Simple Pine Tree" exercise on page 27 to render the foreground pine trees. Vary the heights and spacing of the trees and add as many as you like. Make sure you don't add too many branches. Each tree should look like the wind can blow right through it.

4 Create the Meadow Contours

Mist the bottom half of the canvas with water and add a generous, even coat of white gesso with a clean wash brush.

Create a pale grayish purple mixture of mostly white, a touch of blue and a speck each of red and sienna. Working quickly so that the white doesn't dry, scuff in the meadow's shadow pockets with a fan brush. Hold the brush flat and work horizontally, following the slope and lay of the land. Don't just paint the shadows straight across. There's a word for that—boring! Make sure the bottom corners of the canvas have darker shadows to help draw the viewer's eye to the bright center of the canvas. Add as many shadows as you like, but leave plenty of white showing. This is snow, after all.

Snap Your Own Reference Photos

If you have the opportunity to do so, tote your camera with you and take your own reference photos. Deer, horses, cows, birds, whatever, they all make great painting subjects!

5 Add the Meadow Grass

Mix the stubbly meadow grass tone with white, a touch of sienna and a speck of blue. Load the fan brush by tapping the bristle ends lightly into the paint mixture to create a spiky end quality. Touch the brush lightly on the canvas and pull up slightly to render the small, distant grass clumps. For the taller clumps touch the brush to the canvas and pull up and away. If done correctly, you will get a rough, almost dry-brush effect, which is desirable. Notice that these grass clumps, like the shadows, also conform to the contour of the land. Generally speaking, less grass suggests deeper snow while more grass depicts shallower snow. Which look do you prefer?

You can refine and add detail to the closer clumps using the grass color mixed in this step. Using the script liner, thin the mixture with water and pull individual blades of grass from the bottom of the clump upward, letting them sway to-and-fro. See the "Grass Clumps" exercise on page 61 for more instruction.

6 Transfer the Sketch and Block In the Doe

Let your painting dry completely, then transfer the doe sketch to the canvas. Remember, never place your subject in the dead center of the landscape. It will not be visually interesting.

Use a no. 2 round to block in the doe's midtone color with a grayish brown mixture of white plus a touch of both sienna and blue.

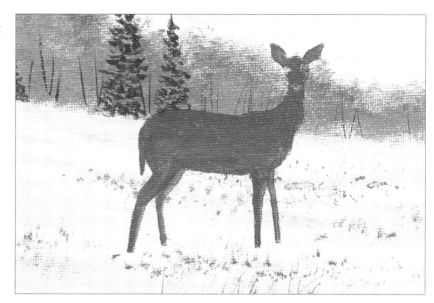

7 Render the Facial Features

Mix a darker value of blue and a little sienna for the eyes and nose. Load the script liner to a fine point and carefully paint the eyes, nose and the dark outline of the ears, then let the canvas dry. Wipe the liner brush and add a touch of pure white inside the ears. Also use the liner to add a sliver of white above and below the eyes, and to dab in the white markings above and below the muzzle (bottom lip area).

These animals commonly have a white patch just below the muzzle, on the throat. For this marking, create an off-white mixture from white, a touch of blue and a speck of sienna. This adjustment is necessary to maintain the muzzle and throat as separate planes. Tap this value in with the fine point of a script liner. If needed, highlight the bottom muzzle with even more white to achieve greater contrast.

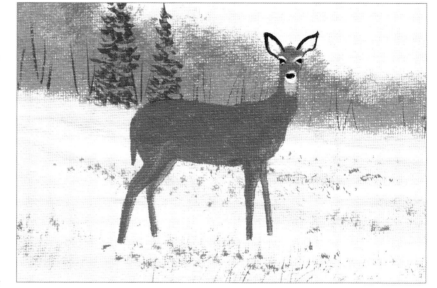

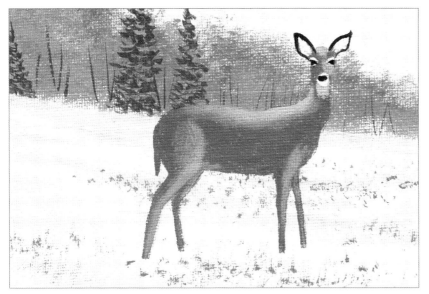

8 Add the Highlights

Mix some white with the doe's midtone color from step 6 to create a highlight value. With the no. 2 round, deposit the mixture along the back and front of the two legs closest to the viewer, front and rear. If the highlight color does not contrast against the background trees sufficiently (if the two browns look too similar), add a slight touch of yellow. This will change the tone just enough to keep the areas from merging.

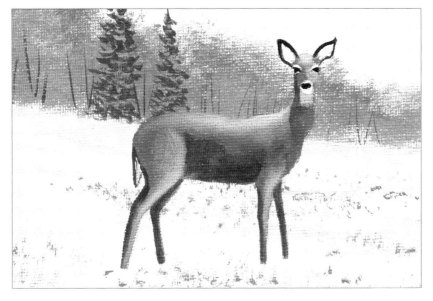

9 Finish the Doe

Mix the doe's darkest accents with sienna, a little blue and a touch of white making sure the value is a little darker than the midtone color. Using light pressure, dab the mixture on the left side of the neck, the tail, the underside of the belly and both of the distant legs.

Finish the doe by dabbing a tiny marking of white fur on the inside of its tail. Ultimately, the doe's overall appearance is achieved with light, midtone and dark values. Adjust and balance these values accordingly.

10 Create the Doe's Cast Shadow

To anchor the doe in the meadow, create a cast shadow on the snow with a dark bluish gray mixture of a small amount of blue and a speck each of red and sienna. Keep the mixture slightly more watery than usual, and avoid using too much paint on the no. 2 round. This will yield a more transparent look that is great for shadows. Note that the shadow falls beneath and to the left of the doe.

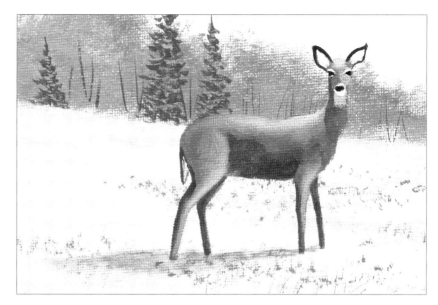

11 Add a Tree to the Foreground

Add another tree to break up the horizon using the same pine tree mixture from step 3. Let the paint run out of the brush as you work toward the bottom of the trunk to allow the tree to sink into the snow. Use your finger to blend the base of the tree into the snow to achieve a soft edge. Because this tree is below the horizon, create a simple gray cast shadow that falls in the same direction as the doe's. Use the gray tone from step 10 and base in with a clean round brush.

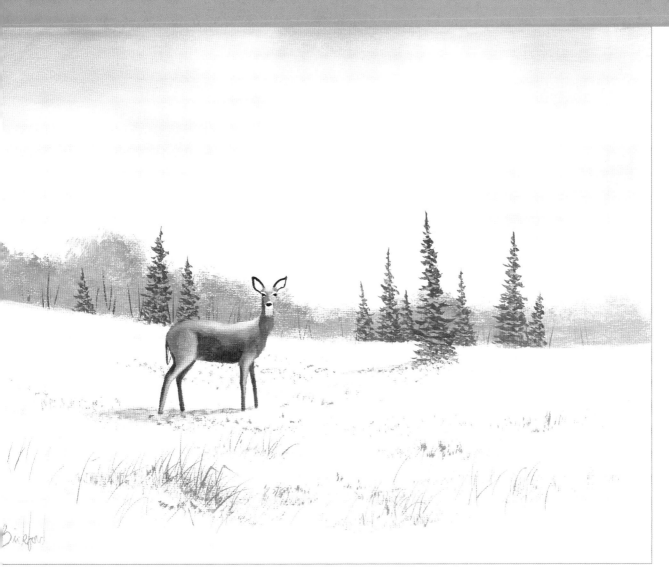

Winter Doe
Acrylic on canvas panel board
12" × 16" (30cm × 41cm)

12 Add the Finishing Touches

Analyze, scrutinize and adjust your painting until you are completely happy with the end product. Add a few more grass clumps or distant pines if you like. You can even add some more fluffy clouds with a clean fan brush and some pure white. Remember to keep your wrist working fast and loose and apply the paint to the canvas with quick, light pressure on just the ends of the bristles. The possibilities are endless. Get creative and use your imagination!

In upstate New York, where I've lived all my life, Canada geese are a common sight. You'll find them grouping around any body of water during most of the year. In the fall, you'll see their familiar flying V-formation silhouetted against the sky as they make their way south for the winter. That is a sure sign for Northerners that brisk temperatures are soon to follow. These honkers, as they're known, congregate heavily at U.S. state parks and campgrounds and thus are considered to be a nuisance by many.

However, as with most animals, I enjoy their company and love incorporating them into my paintings. The males and females look alike, so it's not possible to distinguish them visually.

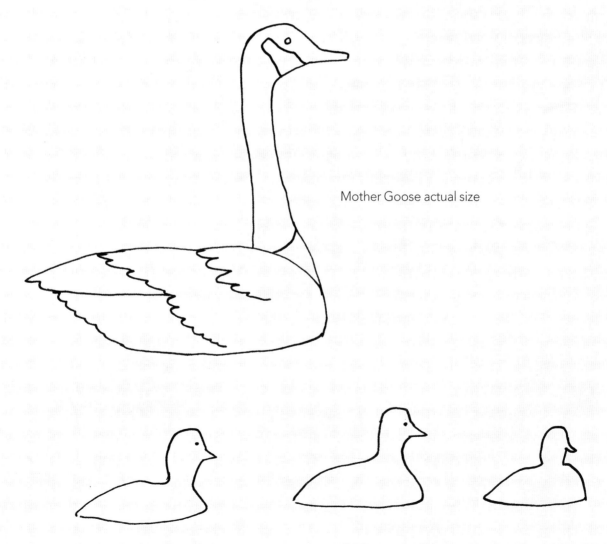

Mother Goose actual size

Goslings actual size

Sky

Background trees

Low shrubs/ foliage

Shadows on white

Body highlights

Neck/head

Body base color

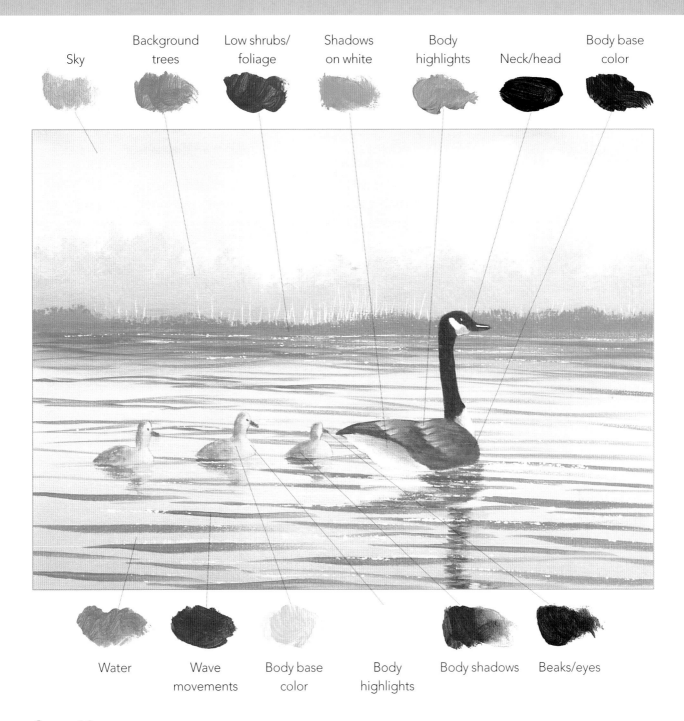

Water

Wave movements

Body base color

Body highlights

Body shadows

Beaks/eyes

Color Mixtures

Background sky; background trees; low shrubs and foliage; water; wave movement; mother goose's body base color, body highlights, shadows on white cheek patch, breast and rump; the goslings' rumps, base color, shadows, body highlights, beaks and eyes

1 Begin the Background

With a pencil, draw a line to indicate the horizon an inch or so above the center of the canvas. Above the line is the sky and below it is the water. Dampen the sky area with the mister bottle. With the wash brush, cover the sky area with a layer of gesso, striving for even distribution.

Add some blue to the brush to achieve a sky value you like, and begin painting with a random, light dry-brush action. Be careful to leave some of the white value behind to indicate cloud movement. A blotchy sky is much more interesting than a flat, solid sky, and will elicit a feeling of depth. When your sky is covered the way you like, wipe the brush on a paper towel and use large, crisscross strokes to soften any harsh brush marks. (Refer to "Wet-Into-Wet Backgrounds" on page 13.)

2 Create the Distant Treeline

While the sky area is still wet, load the no. 3 fan with a muted green mixture of white, blue, yellow and a touch of sienna. Using the corner of the brush, define the top edge of the treeline with scrubbing, circular strokes. Use a little less paint on the brush to gain more control in achieving a wispy, hazy, distant look. Bring this color down to the horizon line. Drag the end of the bristles horizontally across the horizon line to add a crisp edge against the shoreline.

Use the tip of the painting knife to score lines through the green paint to suggest thin trees, such as birches or aspens. In reality, you are removing paint from the canvas. This needs to be accomplished before the paint tacks up and becomes too dry. If the lines look too much like scratches, take a damp no. 3 fan with a little of the value mixed in this step and brush slightly over the scratches to soften them up. Create a few more tree marks towards the middle (i.e. focal point) of the canvas, above where the goose will eventually be transferred.

3 Tap In the Shoreline

Darken the value of the muted mixture from step 2 with a little more blue and a dab of yellow. Tap the top of the no. 3 fan directly into the palette, then with the same tapping motion, add some closer foliage along the shoreline. Remember, darker values appear closer, so this will give the landscape another layer of depth. Strive for uneven, natural bushes, adding the muted tone directly over the top of the scratched-in trees from step 2.

4 Begin the Water

Dampen the pond area with the mister bottle and coat the entire area with white gesso using the wash brush. Without cleaning the brush, dip it in blue and base in the water. Start at the bottom of the canvas and work up towards the horizon line with wide, horizontal strokes. A uniform value is not really needed, but your brushwork should be horizontal.

5 Add the Tree Reflections

Add reflections of the distant trees while the pond's base color is still slightly wet. Create a smudgy, irregular appearance just below the shoreline with the no. 3 fan and using the muted green color from step 2. No specific details are needed, just a general hint of the tree color in the water. Paint in a horizontal brush direction striving for an approximate mirror image of the trees. Taller trees reflect lower into the water toward the bottom of the canvas and shorter trees extend down less. Let the painting dry completely.

Moving Water Yields Distorted Reflections

Since the water will appear to be moving after you add waves, the reflections should be distorted. Exactness isn't critical.

6 Paint the Wave Lines

This step really makes the water come to life. Create a dark-blue mixture by adding blue and a little sienna to the sky tone from step 1 with a no. 10 bright. Load the brush to a sharp chiseled edge and paint the choppy, horizontal wave movements. Work in a back and forth manner across the canvas, so the chiseled edge is horizontal or flat against the canvas (see the "Wave Lines" brush technique on page 22). Make the waves slightly larger and darker near the bottom and a little less distinct towards the shoreline by using less paint on the brush as you work up the canvas and into the distance. Make sure that some of the wave lines/ripples overlap the tre-e reflections to anchor the reflections into the background. Add water to your brush if it gets too dry to minimize the appearance of dry brushstrokes on the canvas.

7 Add Water Sparkles

Follow the exercise on the facing page to create sparkles in the water. Apply the white lines more dominantly in the middle of the painting and less dominantly near the edges to draw the eye to the center of the canvas. The canvas *tooth* (or texture) will also enhance the water's sparkly appearance.

Water Sparkles

EXERCISE

Render a glittery and realistic ripple effect in your water scenes using just the painting knife and a touch of white paint. Practice this technique a lot—it will pay off in your paintings.

MATERIALS LIST

TOOL
Painting knife

COLOR
Titanium White

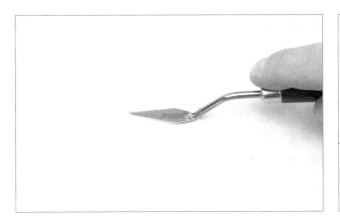

1 Pull a layer of white across your palette in a thin puddle then wipe the blade clean.

2 Drag the long edge of the blade through the thin layer of paint to achieve a very small ribbon of white on the knife.

3 With a horizontal touch-and-drag motion, apply little ridges of white throughout the water area to add shimmering sparkles.

Take Care of Mistakes Quickly

If you get too much paint on the canvas (a "blobby" edge), immediately wipe the canvas clean with a damp paper towel and start over.

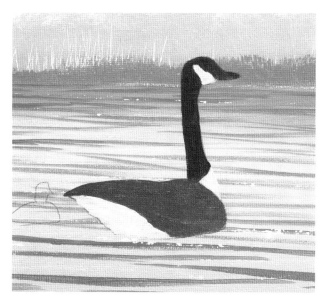

8 Block In the Basetones

When the painting is completely dry, transfer the sketch of the mother goose and her goslings using graphite paper. Refer to the finished painting on page 43 for approximate placement.

The mother goose's long neck is painted with a dark mixture that appears black, but is actually made from equal amounts blue and sienna. Adding a small amount of red will darken this value as well. Base in the color of her neck and head using the no. 2 round. Paint one or two extra coats to achieve a dark value. Add a touch of white to this basetone and block in the main body shape.

Paint the cheek patch, breast and rump with white using a clean no. 2 round.

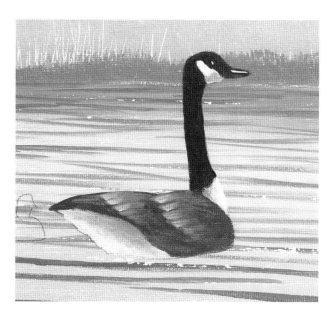

9 Render the Feather Shadows and Highlights

Create an off-white, blue-gray mixture comprised of mostly white, a small amount of blue and a touch of sienna and carefully render the shadows under the chin, on the base of the neck and rump. Use the same no. 2 round from step 8, wiped clean on a paper towel. Make sure the shadow mixture is dark enough to create a contrast against the white value. To suggest roundness in the body, soften the transition with the round brush using dry, crisscross brushstrokes.

Add a little white to the dark basetone mixture from step 8 and block in the brown body and general wing shape with a no. 2 round. Add a touch of white to the base color to obtain the wing's highlight value and develop the rows of feathers using a no. 2 round. This will detail the goose's body and give it some volume. Make sure to paint the feathers from back to front (tail to head) to yield longer and more sharply defined edges.

With the script liner and a little white, touch a dot to represent the *catchlight* (reflected light in the eye), and place a sliver of highlight on the top of the beak.

Painting Order for Mother Goose

1. Neck/head
2. Brown body
3. White patches
4. White to brown for back feather highlight
5. Blue to white for shadows on white
6. Dot the eye and beak

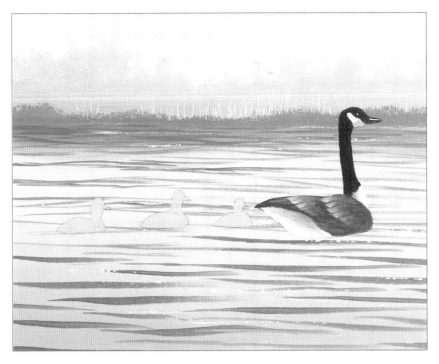

10 Block in the Goslings

Onto the goslings! Base in the midtone first so you can easily adjust the lighter highlights and darker shadow values. For the chicks' shapes, create a mixture using white, a touch of yellow and a speck of sienna. Base this in using a no. 2 round. You want to have contrasts lighter and darker than this value to give round form to the goslings' bodies.

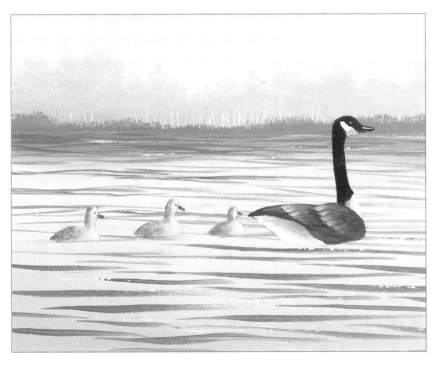

11 Create the Goslings' Highlights and Shadows

Using a no. 2 round, dab highlights on the chicks' right sides with a mixture of white and a little yellow. Mix a darker shadow value by adding a fair amount of sienna and a touch more of yellow to the highlight color for the shaded portions of the chicks' left sides. Make sure you create enough to use for the reflections of the goslings in the water. With a liner brush, darken the left-side highlight value with a touch of sienna, then paint each gosling's small beak and dot the eyes.

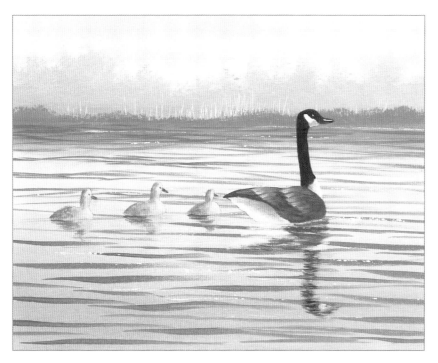

12 Add the Reflections
Take all of the color mixtures used to develop the mother and goslings and apply the same colors to represent the corresponding reflections. Use the no. 2 round or script liner (whichever is more comfortable for you) to dab horizontal strokes below the geese, mimicking their reverse (mirror image) shapes. Absolute exactness is not required. Apply the paint in broken, dashed, jittery lines that suggest and conform to the movement of the water.

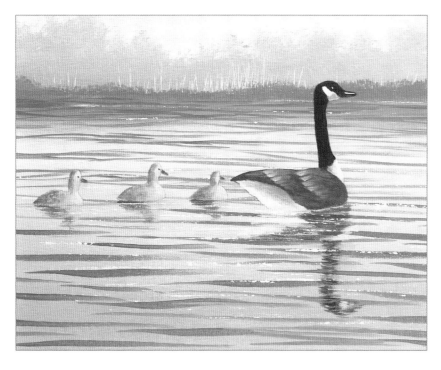

13 Add More Sparkles
Add a few more sparkles to the mother's and goslings' reflections with the painting knife to create the illusion of moving water.

Reference Points
Use a pencil to mark imaginary reference points that mirror the actual body shapes. This will help you gauge how far down to paint the mirror images.

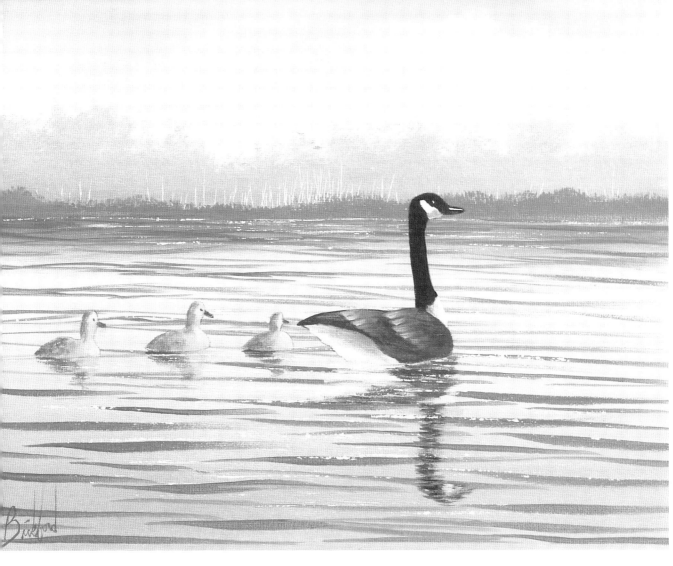

Follow Me
Acrylic on canvas panel board
12" × 16" (30cm × 41cm)

14 **Add the Finishing Touches**
Using the corner of the fan brush and a touch of white, develop the fluffy part of the large cloud. Use a gentle dry-brush technique, pulling down on the brush to blend the cloud into the rest of the sky background.

Create a light-brown mixture with white, a touch of sienna and a dab of blue. Use the script liner to paint in a thin bank of dirt along the shoreline. This light-brown value contrasts well against the greens of the foliage, breaking the edge of the shoreline to make it pop.

Look over your painting and make any other needed adjustments that are easy to add, such as further defining the shoreline with sparkles. Check the contrasts for a final time and tweak accordingly, making the darks pop forward and the light values recede. Don't forget to sign your painting!

Mom and Cub

Black bears are shy creatures, so encounters with them are usually fleeting. However, they have been known to break down the door at hunting camps in search of a snack. While they appear docile and cuddly, they are powerful and deserve much respect. Enjoy them from a distance!

I recently came across one as I was driving along a backcountry road near my home. As my van crested the hill, about 50 yards straight ahead in the middle of the road, a large, black beauty was lumbering across the highway. When I stopped to observe, it hustled into the brush. Perhaps I'll get a better look next time.

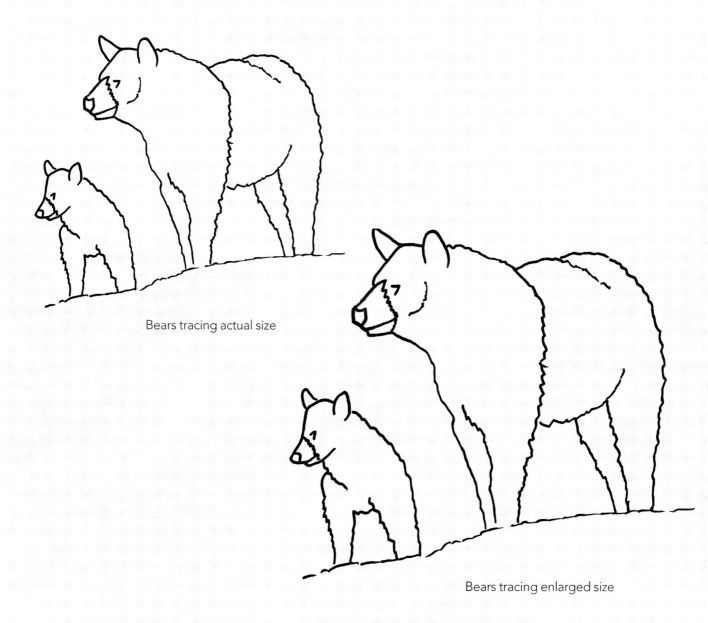

Bears tracing actual size

Bears tracing enlarged size

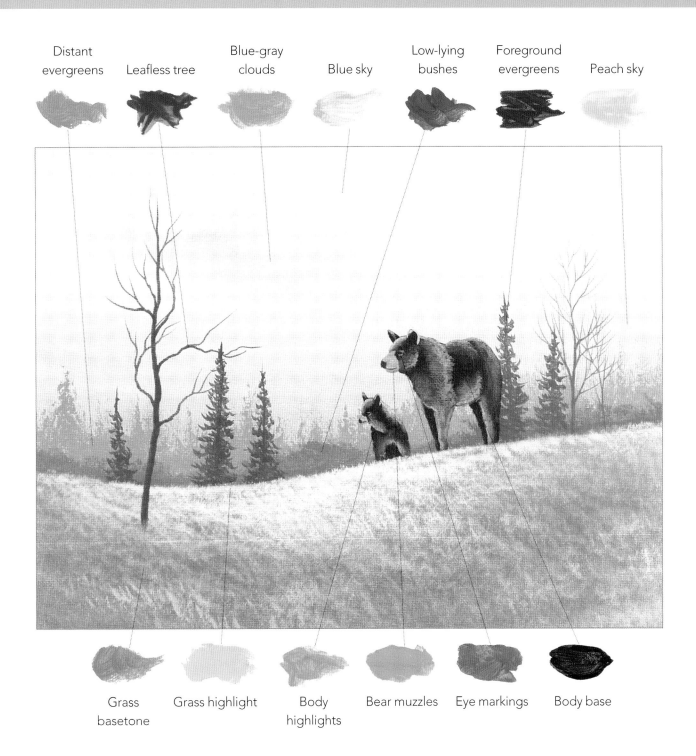

Distant evergreens

Leafless tree

Blue-gray clouds

Blue sky

Low-lying bushes

Foreground evergreens

Peach sky

Grass basetone

Grass highlight

Body highlights

Bear muzzles

Eye markings

Body base

COLOR MIXTURES

Peach sky; blue sky; blue-gray clouds; distant evergreens; low-lying brush; foreground evergreens; dark-green grass; grass highlight; leafless tree; bears (base color, muzzles, highlights and eye markings)

1 Begin the Background

With a pencil, draw the slope of the field. It is just below the halfway point of the canvas and includes an interesting contour. Spritz the entire area above the line with the mister bottle.

Apply an even coat of gesso to this sky area using the wash brush. To achieve a peachy sky color, pick up a little red and a small amount of yellow and work them evenly into the gesso-covered bristles. Using long, horizontal brushstrokes, paint this color above the line and work the value all the way up, smoothing as you go. Immediately wipe the brush and dip it into some blue to establish the tone of the upper sky. In a similar fashion, paint this color across the top and down, blending it gradually into the peach color. Wipe the brush and finalize the blend with light criss-cross strokes.

2 Add Darker Cloud Shapes

Before this starts to dry, add a few darker cloud shapes. Using the no. 3 fan, pick up a little more blue and a touch of sienna and mix them into the blue sky color on your palette. It should be slightly darker than your sky base color to create contrast on the canvas. To convey cloud motion, scuff the brush in a slightly horizontal direction. Use varying pressure, applying and softening at the same time. As you work toward the horizon, the clouds should appear smaller in size to convey distance.

3 Render the Distant Evergreens

For the distant treeline, create a muted gray-green with some white, blue, yellow and a touch of sienna. Hold the fan brush vertically and tap into the canvas to create the irregular, natural-looking silhouette of a treeline (see page 23 for a visual of the "Vertical Chisled Edge" brush technique). The canvas can be wet or dry—if it's very wet, you will achieve softer edges. Fill this color down to the horizon line.

Turn the brush horizontally to fill in the base of the treeline near the horizon. It doesn't have to be a perfect edge at this point, as the brush and grass added in the next step will cover any mistakes.

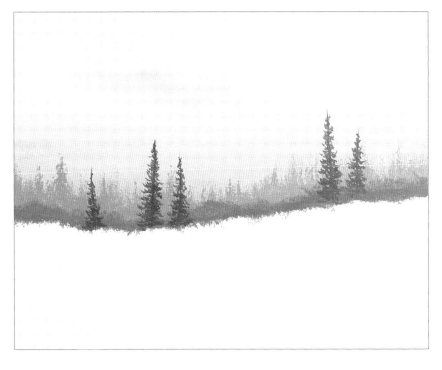

4 Add Foliage and Nearby Pine Trees

Add a touch of blue and yellow to the no. 3 fan to slightly darken the value from the previous step and tap in some low-lying foliage and bushes just above the horizon line. Tap the bristles on the canvas to achieve a chiseled edge. Allow for some unevenness and height variations to create the appearance of natural brush.

Review the exercise on page 27 for rendering pine trees, then use the script liner to add the nearest pines with a much darker green mixture made up of the treeline mixture from step 3 and a little more blue, yellow and a touch of sienna. Remember to thin the consistency with water and vary the heights and spacing. Pull the trees all the way down to the horizon line, over the low-lying foliage.

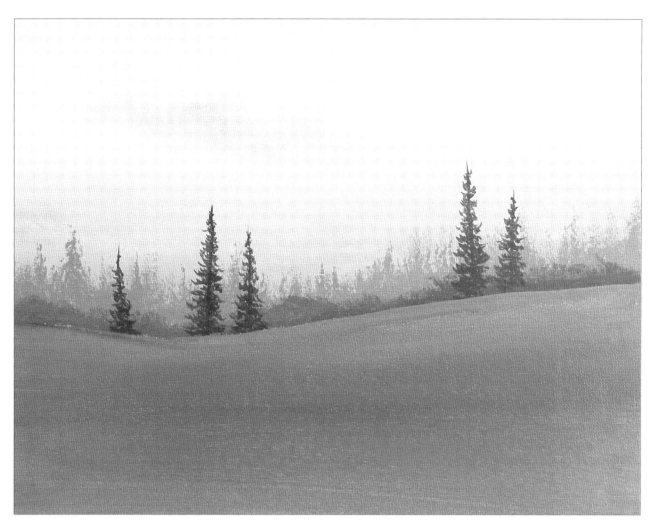

5 Block In the Grass

Using the flat wash brush, block in the entire land area with a dark-green mixture of mostly blue, some yellow and a little sienna. Your brush-work should follow the contour of the land, conforming to the direction of the slope. Holding the brush horizontally, use the ends of the bristles to create a crisp defined line at the horizon. Reload the brush as often as necessary and avoid drybrushing to fully cover the tooth of the canvas.

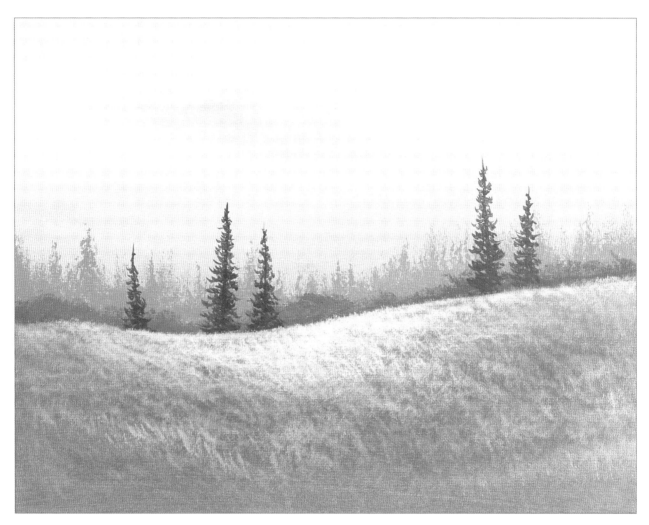

6 Add the Grass Highlights

Create the lighter, yellow-green highlight mixture by adding some white, a little yellow and a touch of blue to the grass tone from step 5. Load the wash brush (it does not have to be totally clean from the previous step) and tap it in a slight downward motion across the horizon to create stubbly grass effect. (See "Large Grass Areas or Background Trees" on page 23 for a visual of the brush technique.) Bend the bristles to a scraggly tip (not smooth or pointed), and work down and across from the top of the hill. Create a bright focal point in the center of canvas to draw the viewer's eye to the animal subject's eventual location. Vary the pressure of your brushstrokes to create lighter accents, but still make sure to keep plenty of the dark value showing through. As you work toward the edges and bottom of the canvas, gradually scuff the paint from the brush to enhance the transition from light to dark. The midtone should be more toward the middle and bottom of the canvas.

Create more texture on the grassy field with a slightly damp wash brush. Rinse out the green completely and tap the brush in white, bringing the bristles to a spiky tip. Suggest the texture of grass with a light, dabbing touch, pulling slightly downward for taller grass.

Experiment With Highlights

Tap in various yellow and green grasses with the wash brush to add a fullness to the land. Make sure to bring the bristles to a spiky tip.

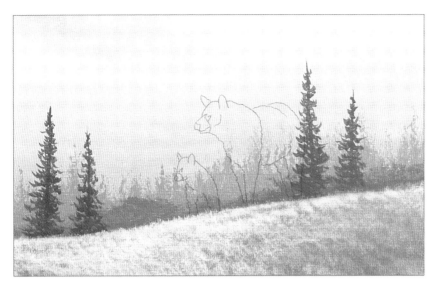

7 Transfer the Bears

When the painting is completely dry, transfer the bear and cub sketch using graphite paper and a red pen. (See "Transferring Sketches" on page 15 for instructions). Refer to the finished painting on page 53 for approximate placement.

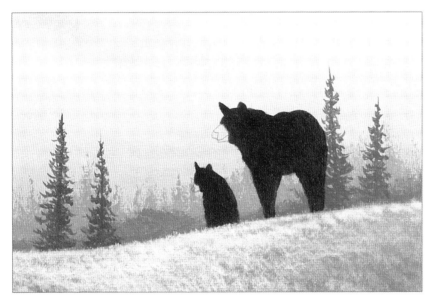

8 Block In the Bears' Basetone

Create the bears' body color with equal portions of blue and sienna, and a touch of red and block it in with a no. 2 round. Use two coats of paint to make the fur dark enough, allowing the paint to dry between coats. Pull from the outsides of the bears in to add more definition to the ends of the hairs. (For the lower body, pull from the feet in toward the top of the leg and back in toward the stomach area.) For the smaller areas, use the script liner loaded to a fine point.

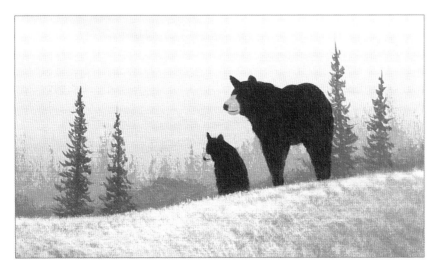

9 Add the Muzzle and Nose

Mix the bears' muzzle color using white, a little sienna and a touch of yellow, creating a fleshtone. Block in the tone with a no. 2 round or script liner. Use the script liner to carefully add each bear's nose with the black mixture from step 8, and to paint the line of each mouth.

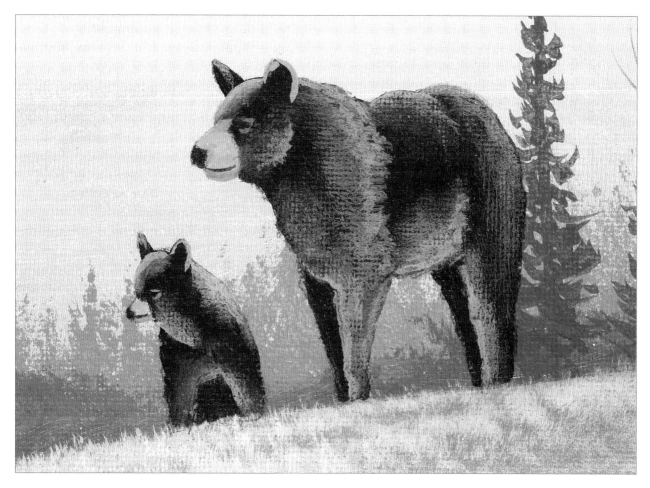

10 Create the Bears' Highlights

It is common to highlight black subjects with blue tones. With a no. 2 round, mix blue and some white and define the larger body shapes—the top of the head, back of the neck, cheek/jowl line, shoulder, belly and rump. (For the smaller facial areas, always pull the paint in toward the face.)

Wipe the brush with a paper towel and lightly blend the highlights' edges to soften them against the black fur, yielding a rounded look for the bodies. Pull these strokes from the tips of the bears' hairs into the center of the body. Remember, you don't need to show individual hairs, but rather, the contours and planes that define the body forms. Note that the legs closest to the viewer receive a highlight value, while the furthermost legs remain in shadow.

Use the liner brush and the same color to add contour and an outline to the ears. Do not let this lighter value overtake the dark values. The bears are black, after all. Sometimes adding a little water to the brush makes it easier to feather blend the edge of the highlights into the body to create the contours because the canvas is so dry.

Black bears have subtle markings of brown around their small, dark eyes. To define and suggest the markings, load a clean liner brush with some of the muzzle color from step 9 and a touch of sienna, then carefully place this color on the bears' upper and lower lids.

Simple Leafless Tree

EXERCISE

Thin, leafless trees are a wonderful way to add character to your landscapes. When portrayed in an autumn backdrop, they suggest which trees have defoliated for the season. During other seasons, they denote older or expired trees. Either way, they appear natural and help your paintings tell a story.

MATERIALS LIST

BRUSH
Script liner

COLORS
Burnt Sienna, Ultramarine Blue, Titanium White

1 Create a thin, fluid grayish brown mixture with sienna, a touch of blue and a dab of white. Using the liner brush, pull up a gnarly, crooked tree trunk bottom to top. Release the pressure of the brush on the canvas as you work downward. Wipe the brush on a paper towel and pull gently on the bottom of the trunk to anchor it into the ground, similar to a dry-brush technique.

2 Draw limbs and branches outward, using light pressure to allow each branch to taper naturally outward into a thin point. As you work, thin the paint as needed to yield fine lines. The trunk will be the thickest part, the limbs a bit thinner and the branches will be the thinnest strokes on the tree.

3 Add as many or as few limbs as you like, varying the spacing of the branches to give the tree a loose and airy feel. Don't be afraid to overlap these trees into the foreground. This will add depth to the entire background.

Mom and Cub
Acrylic on canvas panel board
12" × 16" (30cm × 41cm)

11 **Add the Finishing Details**
Add depth to the landscape by pulling a couple of leafless trees into the background and a larger tree that flows over the edge of the horizon into the foreground. For the two background trees, use the grayish brown mixture as described in step 1 of the exercise on the facing page. Add a touch more sienna for the darker, foreground trees. Make sure to anchor the trees into the grass with a clean brush and gentle, dry-brushing technique.

Take another look at your work. What might you add or improve? Does it need more texture in the grass? More highlights on the bears? These adjustments can easily be made. Have fun with it!

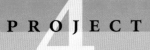
Trolling the Shore

A frequent sight around my neck of the woods is the great blue heron. This large water bird patrols the shallows for hours in search of fish, frogs, insects and other suitable lunch. There is a large marshland a couple of miles from my home that I pass regularly. I often get a glimpse of this magnificent bird as it stalks its prey.

Herons are large for their species, and are an impressive sight when they swoop down in flight to the water's surface. They are adept at using their long bills to stab and impale their catch. I have used them as painting subjects many times.

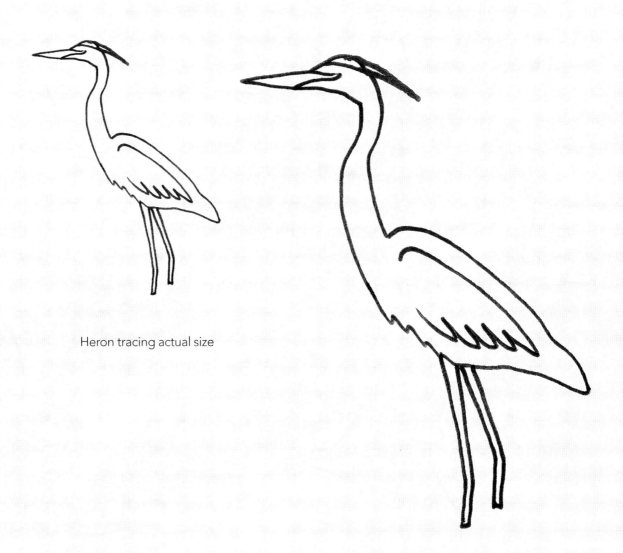

Heron tracing actual size

Heron tracing enlarged size

Tree base

Tree highlights

Tree midtones

Tree trunks

Water movements

Heron beak

Pink water

Blue water

Grass clumps

Blue sky

Light pink sky

Bushes on shore

Light shoreline

Dark shoreline

Head, tail and eye

Heron base

Wing feathers

Heron legs

Brown grass clumps

COLOR MIXTURES

Shorelines; bushes on shore; grass clumps; sky (light pink and blue); background trees (dark basetone, midtone, highlight and trunks); water (pink, blue, wave movements and sparkles); heron (basetone, highlights, dark head, tail, eyes, beak, legs and wing feathers)

1 Begin the Simple Sky

Mark the horizon line with a pencil. It is slightly more than one-third of the way up from the bottom of the canvas. Dampen the sky area with the mister bottle and apply a generous, even coat of gesso using the wash brush. Work a small amount of red into the dirty brush and paint this tint from the horizon line upward. Work broad strokes across the canvas, bringing this color about halfway up through the sky.

Immediately pick up a little blue on the brush and bring this color down into the established pink tone starting at the top of the canvas. Where the blue meets the red, use light X-strokes to achieve a smooth transition and gradation between the colors. This type of blending requires practice, so don't be discouraged. Your technique will improve over time.

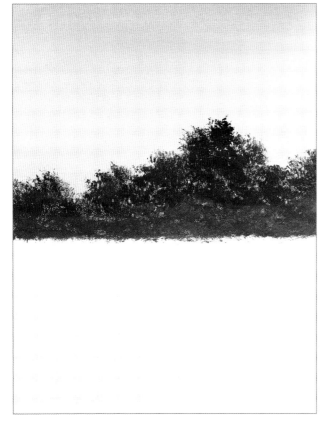

2 Create the Trees' Basetone

Mix a dark-green tree color using blue, yellow and a touch of sienna. Gently tap just the corner of the fan brush to establish the overall shape and contour of the tree line (follow the tree-painting exercise on the facing page). Create interesting round tree shapes, but leave plenty of breathable holes to retain the pink sky color underneath. Paint the dark tree value down to the horizon line.

Indicate the thick underbrush at ground level near the shoreline by turning the brush horizontally and tapping in the dark mixture more solidly. If the paint feels too dry and sticky on the brush, add a tiny drop or two of water to help it flow better from the brush.

Group of Deciduous Trees

EXERCISE

Suggest groups of distant deciduous trees by focusing on their overall shape instead of individual leaves. To achieve a natural look, always use at least three values (dark, middle and light) and random heights and spacings.

MATERIALS LIST

BRUSHES
No. 3 fan, no. 2 script liner

MIXTURES
Burnt Sienna; light, middle and dark values of any color

1 Start with your darkest value, in this case a dark-green mixture of blue, some yellow and a touch of sienna. Lightly tap the corner of the fan brush (turned horizontally) to create interesting round treetop shapes. Make sure to leave plenty of breathable holes to retain the sky color underneath. (See the "Spiky Bristles" brush technique on page 23.)

2 Add a touch of white to the darkest value to create the midtone. Using the spiky edge of the fan brush, lightly tap in the highlight color to break up the dark tone into a bunch of smaller masses. Let the highlight color fade into the darker tone at the base of the trees.

3 Add a bit of yellow to the highlight mixture from step 2. Repeat the tapping motion with the fan brush over the tops of the trees to add even more depth and roundness to the leaves. Keep in mind that the light source is coming from the right side.

4 Create a thin, brownish mixture of sienna, white and a touch of blue for the trunks. Start at the shoreline and create the tree trunks by pulling up random thin lines with the liner brush. Drag a few limbs throughout the higher foliage to support the canopy of leaves. Concentrate more trunks and limbs at the center of the painting to create a focal point to attract the viewer's eye.

Create the orange color mixture with some sienna, a touch of blue and white for the ground underneath the foliage. With a clean fan brush, scuff in this value with horizontal back and forth brushstrokes.

3 Add the Trees' Midtones and Highlights

Add some yellow and a touch of white to the dark-green mixture from step 2 to create the midtone of the treeline. Using the spiky corner of the no. 3 fan, break the shoreline trees into smaller masses, about five or six shapes in all. Visualize the tops of bushes and boughs and tap in a leafy leading edge, letting the color fade down into the darker shadows.

Add some white to the midtone value remaining in the fan brush to create a bright yellow highlight value. Highlight the top edges of the trees sparingly, keeping in mind that the light source is coming from the right side of the canvas.

4 Create Trunks and Limbs

With the no. 2 script liner, create an off-white trunk mixture with mostly white and equal touches of blue and sienna. Thin it with a little water and pull thin trunks upward from the shoreline. Drag a few limbs throughout the higher foliage to support the canopy of leaves. Concentrate more trunks and limbs at the center of the painting to create a focal point that will draw the viewer's eye.

Create the sandy bank color mixture with some sienna and touches of blue and white. With the chiseled edge of a clean no. 3 fan, scuff in the brown value with horizontal back and forth brushstrokes along the shoreline. This will create a sandy beach and add definition and visual interest to the shoreline. Add a touch of white to the sandy color to create a highlighted focal point near the center of the horizon.

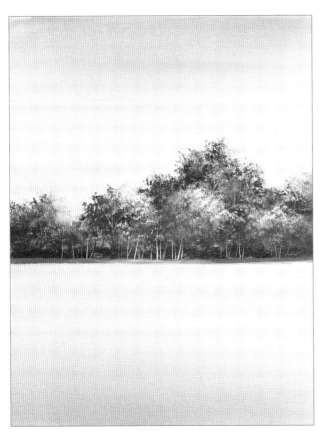

5 Begin the Water

Spritz the water area with the mister bottle and use a clean wash brush to apply a generous layer of white gesso. Add a touch of the pink sky value from step 1 and base in the pinkish hue of the water. Work this color into the canvas from the horizon down, about halfway through the water area.

Add some blue to the brush and paint the rest of the water, starting at the bottom and working in long, horizontal strokes across and up. Overlap and blend this value into the pink to achieve a soft mirror image of the sky.

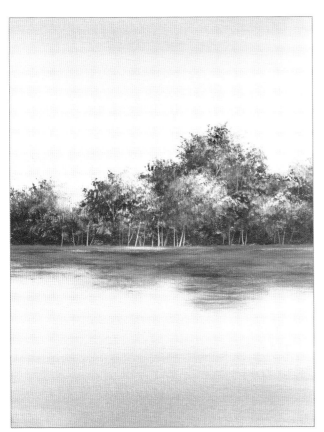

6 Render the Trees' Reflections

Suggest the trees' reflections using the green midtone from step 3. Hold the no. 3 fan horizontally and scuff in smudges of color beginning at the shore and continuing downward toward the bottom of the canvas. Leave some of the pink water color showing through these reflections to give the water the appearance of movement. Add a touch of white to the brush and create the reflection of the trees' highlights. Approximate the general shape of the trees in reverse, striving for a rough mirror image of the trees. Let your painting dry.

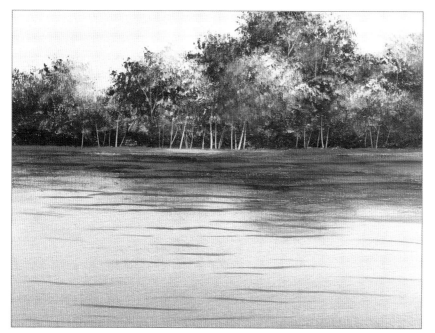

7 Create the Wave Lines
Paint in wave lines to give the water even more motion. Mix a dark-blue color comprised of mostly blue, a touch of sienna and a speck of white and load a no. 10 bright to a chiseled edge. Drag your brush lightly across the canvas in thin, horizontal lines. (See the "Wave Lines" brush technique on page 22.) Put in as few or as many as you wish, varying each wave's length. Remember, fewer lines suggests calm water and more lines give the impression of turbulent water.

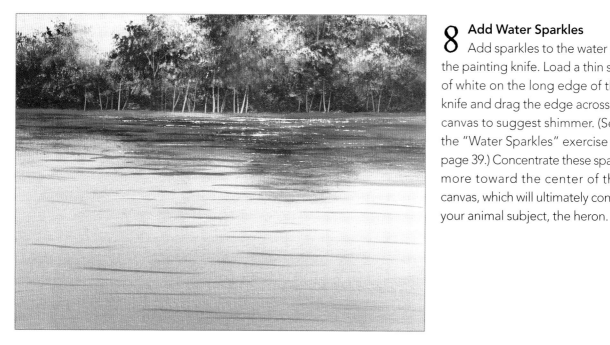

8 Add Water Sparkles
Add sparkles to the water with the painting knife. Load a thin sliver of white on the long edge of the knife and drag the edge across the canvas to suggest shimmer. (See the "Water Sparkles" exercise on page 39.) Concentrate these sparkles more toward the center of the canvas, which will ultimately contain your animal subject, the heron.

Grass Clumps

EXERCISE

Painting convincing grass texture is essential to landscape scenes. Clumps of grass, in particular, can add much interest to your composition. They are great for adding visual texture and detail to lacking portions of the canvas. Place them in snow covered meadows or breaking the surface of a body of water. Just remember, grass and hay colors vary with the seasons—green in summer, golden in autumn and brown in the cold winter months.

MATERIALS LIST

BRUSHES
No. 3 fan, no. 2 script liner

MIXTURES
Light, middle and dark values of any color

1 Mix a dark green value for the grass basetone with blue, some yellow and a touch of sienna. Load the fan brush by tapping the bristle ends lightly into the paint mixture to create a spiky end quality. Touch the brush lightly on the canvas and pull slightly up to render the small, distant grass clumps. Work lightly to achieve a rough, almost dry-brush effect. Generally speaking, a little less paint yields a rougher texture than a fully loaded brush. Add a little bit of yellow and white to the base mixture and pull more grass on top of the main clump.

2 Continue to alter the basetone and middle values to add depth to the grass clump. Create the lightest grass value with yellow, white and a touch of the basetone and pull up a few blades from the bottom with the fan brush. Keep the bristles spread in a spiky fashion by pouncing them in the color on the palette.

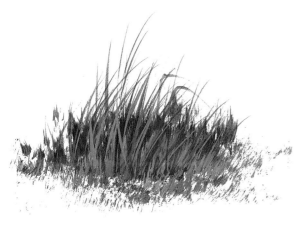

3 Using the no. 2 script liner, thin the light- and middle-value mixtures with water and pull tall, individual blades of grass from the bottom of the clump upward, letting them sway to-and-fro. For a natural-looking taper, be sure to keep your wrist loose and the paint mixture fairly thin.

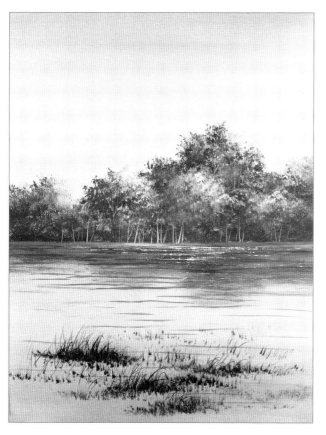

9 Render the Grass Clumps

Create some grass clumps in the foreground to give the body of water a shallow appearance. Mix the dark-green grass mixture with blue, yellow, and a touch of sienna. Touch a loaded fan brush horizontally to the canvas and pull short strokes upward to yield a grass effect (see the exercise on page 61 for more instruction).

Add interesting color variations to the grass clumps by working a bit of sienna into the dirty brush. Dab darker clumps of grass over some of the green clumps. Thin the green grass color with water and use the script liner to pull up a few longer, individual grass blades, beginning your brushstroke at the bottom of each clump. You can also pull up a few blades of grass with the brown grass color.

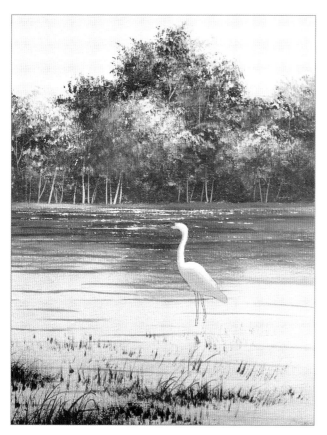

10 Transfer the Heron Sketch

Let your painting dry completely and transfer the heron sketch to the canvas. Use a no. 2 round to block in the heron's head, neck and body with a bluish gray mixture made from mostly white, a little blue and a speck of sienna. To really make the bird stand out, use white on the no. 2 round to place a strong highlight on the heron's head, and down the back of its neck to the shoulder and back. Blend the inside edge of this white with the bluish gray body color to lend roundness to those areas.

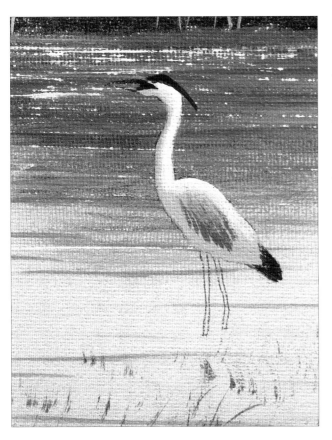

11 Add the Wings and Features

Lighten some of the dark-blue color with just a little more white and suggest the wing feathers. Using the script liner, start at the wingtips and pull the highlights up toward the bird's head to yield the slight texture of feathers. The bird's cap and tail are a dark-blue value mixed from mostly blue, a touch of sienna, and a small amount of white. There is also a sliver of this color near the front face and eye area. Thin the dark-blue mixture and use the script liner to carefully paint these detailed areas.

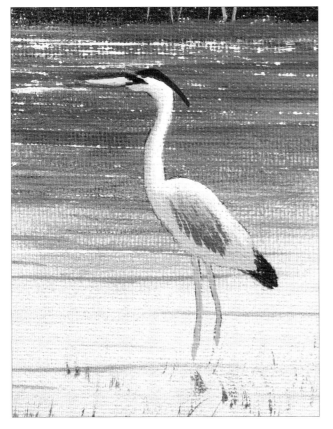

12 Paint the Bill and Legs

Rinse the script liner clean, and use a mixture of white and some yellow to paint the bill and legs. Load your brush to a fine point to achieve a sharp edge for the fine details. Dab a hint of sienna into the script liner to darken the hue of the legs, since a heron's legs are usually slightly darker than its bill.

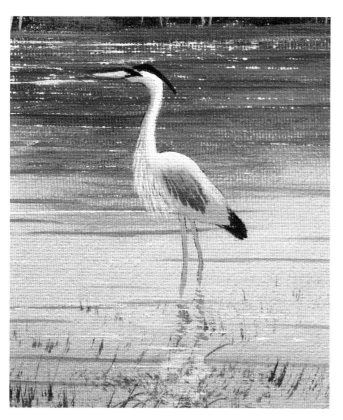

13 Create Feather Details and the Heron's Reflection

Load a little white on the liner and add some fluffy feathers to the heron's chest for lifelike dimension.

Render the bird's reflection to anchor it the landscape and to add an extra surface element to the water. Create these ripples of color using the script liner and the base color from step 10. Dab horizontal lines and dashes in the corresponding areas to suggest a reverse mirror image. Don't try to be overly precise. Even if the bird's reflection turns out somewhat distorted, it will still give the impression of moving water, and that's a plus!

14 Add Some Shoreline Bushes

Create a small mixture of white, yellow and red. Gently tap the fine point of a no. 2 round in a circular, bushy motion to yield many small, red dots. Keep the paint thick on the tip of the brush so the color doesn't blotch together. Aim for a fluffy, spacious texture with the bushes. Don't forget to drybrush the red reflections on the water's edge.

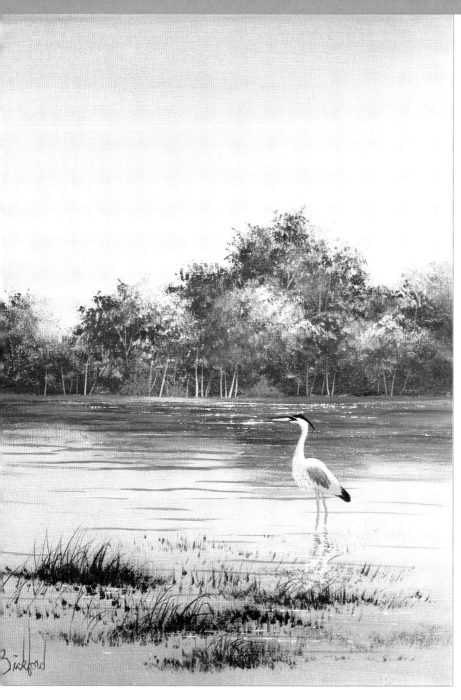

15 Add the Finishing Details
Look over your painting. Are your darks dark enough? Are your lights light enough? Minor alterations in contrasts can make a big difference, so don't be shy of adjustments.

To finish, use the painting knife to add some extra sparkles and ripples around the bird's feet and at the base of the grass clumps. Be sure to place some of these movements throughout the bird's reflection to link the reflection with the water.

Trolling the Shore
Acrylic on canvas panel board
16" × 12" (41cm × 30cm)

Snowy Morn

I enjoy snowshoeing during the winter for exercise and fresh air, and also to take in the beautiful surroundings. The snow-laden trees, white drifts and colorful skies have made for many a nice painting. Whitetail deer occupy the woods behind my home, and I often see their footprints intermingled with my snowshoe prints from the previous day's walk, evidence that they investigate visitors to their domain.

While these animals are hunted extensively in the Northeast, their numbers do not seem to decline. I frequently see them in the meadow behind my home, and they sometimes venture into my front yard to nibble at the low-hanging cedar trees. I am not a hunter and would never harm one of these animals—my shooting is limited to a camera.

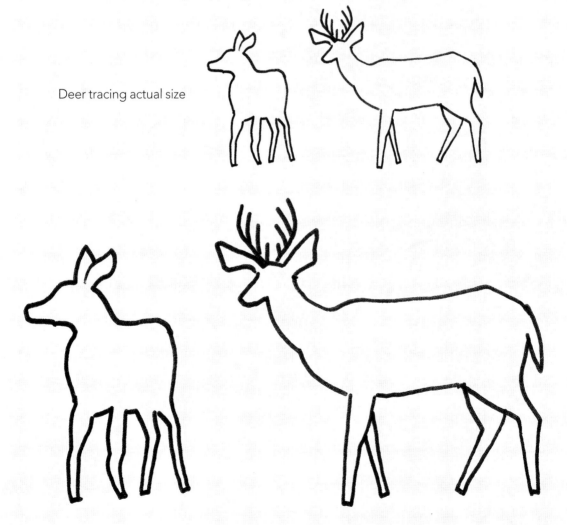

Deer tracing actual size

Deer tracing enlarged size

Background tree and bush base color

Blue-violet sky

Red sky

Yellow sky

Snow shadow for trees

Snow shadow for ground

Grass clumps

Deer base color

Deer highlights

COLOR MIXTURES
Sky (yellow, red, blue-violet); background trees
(basetone and leafless trees/bushes, trees' snow
shadow); snow shadow on ground, snow highlight
(white), grass clumps, deer base color, deer highlights

1 Begin the Background

With a pencil, draw a gentle slope to indicate the horizon line. A gentle slope is more visually appealing than a flat line. With the mister bottle, lightly spritz the sky area. Apply an even layer of white gesso to the sky area using the wash brush. Pick up some yellow on the brush with gesso to establish a glow just above the horizon. Stretch this color upward to the middle of the sky.

2 Blend Red Into the Yellow Sky

Pick up some red on the dirty brush (with yellow and white) and, starting at the top of the canvas, work this color across and down using long, horizontal, crisscrossing X-strokes. Overlap and blend into the yellow to soften the transition between the two hues. Wipe your brush often on a paper towel to help distinguish the colors.

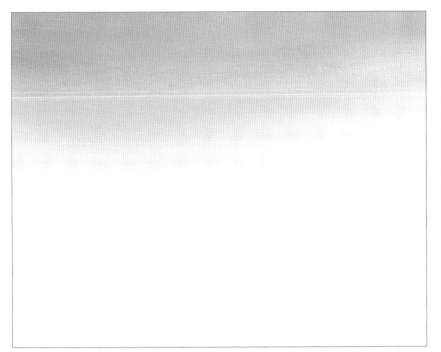

3 **Blend the Darkest Sky Tone**
Add some blue to the brush to darken the very top of the sky, blending it gradually into the red to melt the colors together. Wipe the brush often (or use a clean wash brush if the colors are becoming too blended on the canvas), and use light X-strokes to pull it all together, minimizing your brush marks.

4 **Render the Clouds**
Dip the brush with the blue base color from step 3 in a little white and add it to the lighter red and yellow areas. To render wispy cloud movements, scuff the brush against the canvas horizontally and diagonally. The canvas should still be a little damp, so if you wipe your brush on a paper towel you can soften the edges of the clouds to fuse them with the colored background.

Snowcapped Tree

EXERCISE

Beautiful, snow-laden trees are essential to a winter landscape and add much visual interest. Outside in the winter wilderness, you can often hear them cracking and creaking under their heavy loads. They are not difficult to paint so let's give it a go!

MATERIALS LIST

BRUSH
No. 2 round

COLORS
Burnt Sienna, Cadmium Red, Titanium White, Ultramarine Blue

1 Mix a purplish tree color with mostly blue, a touch of sienna and a touch of red. Use a no. 2 round to pull up a vertical trunk line from bottom to top. Use light pressure so the trunk remains thin, as a guideline for the center of the tree. Create the beginning of small branches by dabbing the brush horizontally, pulling left and right from the center outward.

2 Start at the top of the trunk and continue to widen the branches gradually as you near the base. Vary the height and spacing of each branch to give the tree an airy feel. Thin the paint slightly with water to help the brush move swiftly down the tree.

3 Mix the snowy highlight with a bit of blue and white. Dab the indication of snow-laden branches onto the trees using the same approach as in step 1. Leave plenty of background showing through to create spaces between the branches, giving the trees fullness and volume.

4 If you wish, you can add more white to the snow color from step 3 and apply a second highlight to some of the branches. Always keep in mind the direction of the light source so you place your highlights properly.

Mix Up Your Tree Branch Colors

It is best to use a dark value for snowcapped tree branches to contrast the snow tones. While any dark value will do, I prefer a rich violet hue over a more ordinary green. Don't be afraid to experiment. For a grayish blue, mix sienna and blue; for a traditional green, mix a touch of white with blue and yellow.

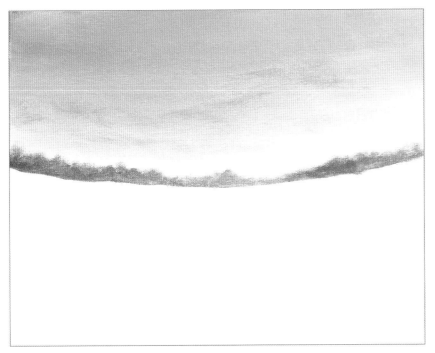

5 Establish the Distant Trees

You can either begin the trees and shrubs while the sky is wet, or after it has dried. Either way is fine. Mix a dark, muted violet with mostly blue, a little sienna and a touch of red. Place a little of the mixture from step 3 on the wash brush. Holding the brush flat against the canvas, use the sides of the bristles (not the tips) to tap and scuff the rough-looking shrubbery. Strive for an interesting, irregular outline. (See page 23 for a visual of the wash brush technique.)

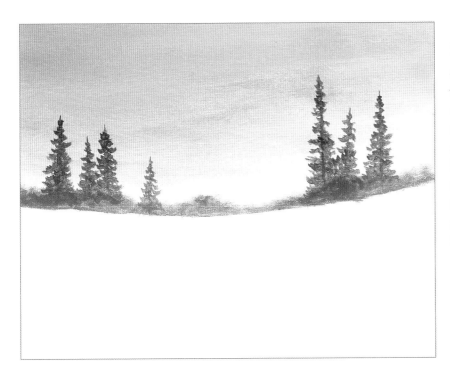

6 Add the Foreground Trees

Render the large foreground evergreens with a no. 2 round and the tone from step 5. Follow the exercise on the facing page for more detailed instruction. Make sure to use a fluid mixture on the brush. The dry canvas tends to absorb most of the moisture and may cause a dry-brush effect, preventing the paint from filling in the tooth of the canvas.

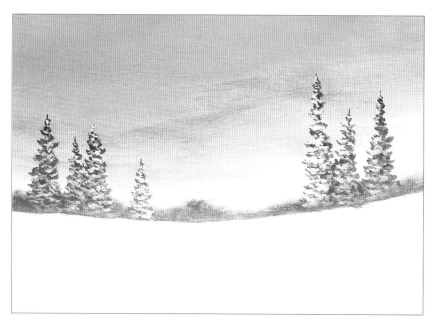

7 Add Snow and Highlights to the Trees

Rinse the round brush clean and mix a fairly large amount of the midtone shadowy snow color using white and a touch of blue. Dab in the indication of snowy branches, keeping the strongest highlights on the trees near the middle of the painting—the central focus of the viewer's eye. Refer back to the exercise on page 70 for more detailed instruction on painting snowcapped evergreen trees.

8 Block In the Contour of the Land

Mist the bottom of the canvas and apply a generous layer of gesso. Dip the brush in touches of blue and red and completely cover the area. This will represent the snow's base shadows.

Pick up a bit more blue and paint with a vertical, back and forth motion across the bottom of the canvas, keeping the whitest snow in the center where the deer will be placed. The darkest blues will be in the lower left- and right-hand corners.

When this base color is dry, suggest the contours of the meadow using some white with a little blue on the no. 10 bright. Use horizontal, scrubbing strokes and follow the lay of the land. Emphasize the horizon in the middle of the canvas by using only pure white. This will draw the viewer's eye to that spot, where the deer will ultimately be placed.

Creating Wispy Grass

Make sure your paint is moist enough to achieve a wispy grass effect. Add a drop or two of water to your mixture as necessary.

9 Render the Grass Clumps

Create the patches of grass with the no. 3 fan and a dark-brown value of mostly white, sienna and a touch of blue. Follow the exercise on page 61 to render the meadow's grass clumps. Your grass clumps should follow the lay of the land. Wipe the brush on a paper towel and add sparing touches of pure white to suggest snow or frost on the grass.

Thin the grass color with water and use the script liner to detail the closest clumps. The large size of the blades will make the clumps appear nearer and create more depth in your painting. Drag your brush upward with light pressure from the bottom of each grass clump to give the grass a natural taper.

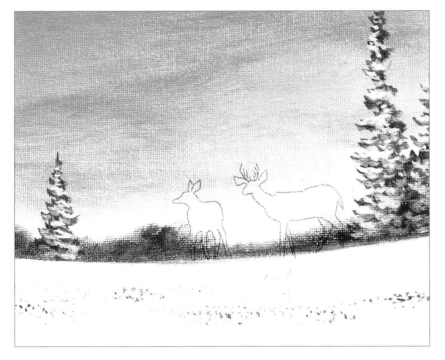

10 Transfer the Deer Sketch

Transfer the deer to the canvas after it dries completely. Place them slightly off center, or refer to the finished painting on page 75 for guidance.

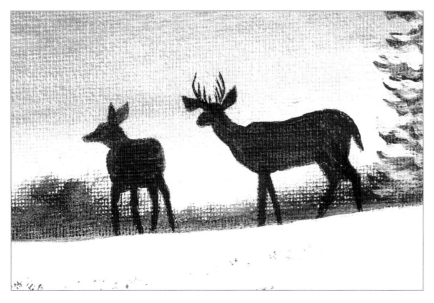

11 Block In the Deer Shapes

Using the no. 2 round and the no. 2 script liner, paint the deer body shapes with the tree and shrub color from step 5. Apply two applications of paint if the first base tone is too transparent, letting each coat dry in between. Remember, thin paint will make thin lines, so use a little water on the no. 2 script liner for detailing the delicate antlers and legs. The antlers require a steady hand, and it may help to brace your wrist while you paint to achieve the small details. Let the paint dry first so you can rest your hand on the dry canvas without smudging your work.

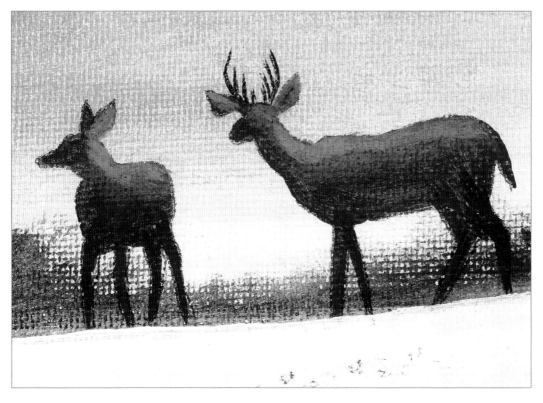

12 Add the Body Highlights

Minimal highlighting is needed for this backlit scene. Use a mixture of sienna and a little white to apply a lighter contrast to the deer necks, upper backs and top edges of the ears. Gently dab in the paint where necessary with a clean liner, then drybrush the paint with a wiped brush to soften the highlights.

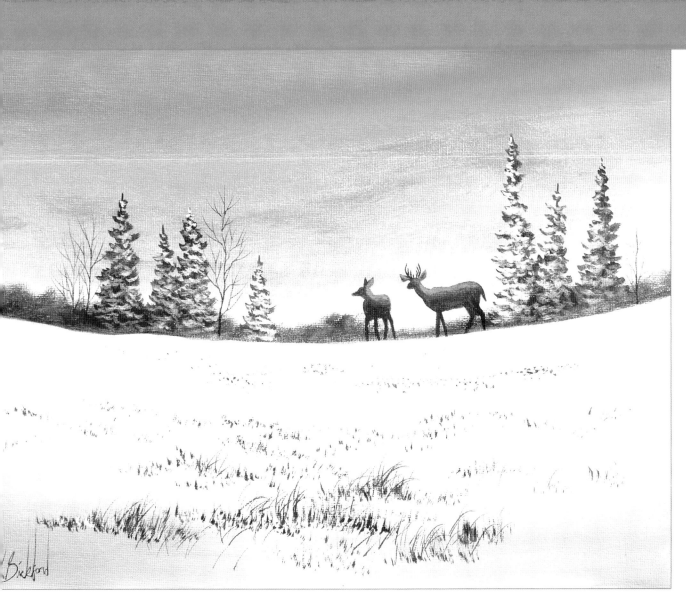

Snowy Morn
Acrylic on canvas panel board
12" × 16" (30cm × 41cm)

13 Add the Finishing Details

Assess your contrasts. Lighten, darken and define. Make any adjustments you think will add to the painting. I used the violet value from step 5 to add a few simple, leafless trees. Since the far-off distance is mostly in silhouette, you can use this mixture for most objects in the background scene.

Loons on the Lake

Loons inhabit many of the lakes, ponds and rivers of northern New York and the Northeast in general. Sylvia Lake is a popular spot located a couple of miles from my home that attracts these diving birds. Their distinctive call has been described as a cross between a laugh and a yodel, and it carries a remarkable distance across calm water. Because their feet are situated far back on their bodies, loons are not suited to moving on land and avoid coming ashore except to nest. However, this physical trait also makes them powerful swimmers. The females are smaller, but otherwise look similar to males. I've seen groups of these birds bobbing on the lake many times, which has inspired several paintings like this one.

Loons tracing actual size

Loons tracing enlarged size

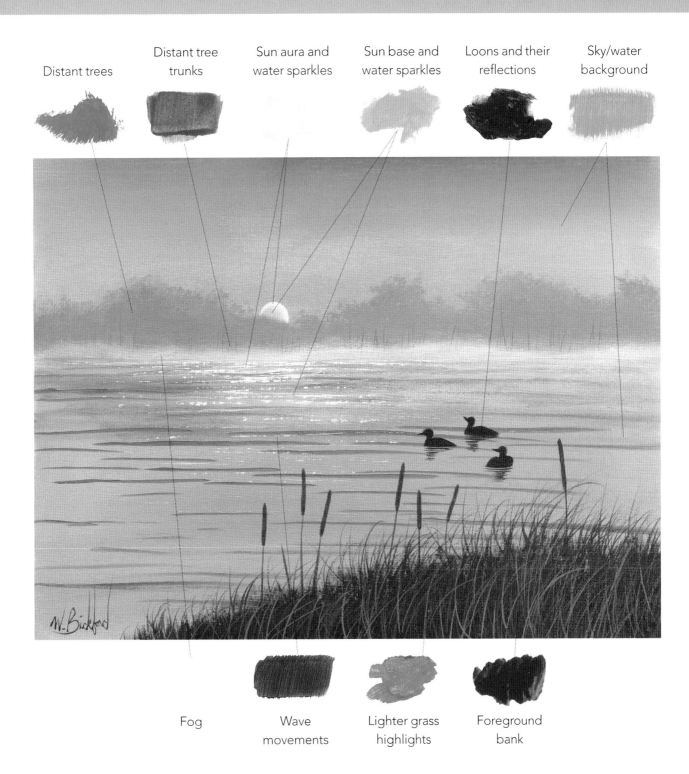

Distant trees

Distant tree trunks

Sun aura and water sparkles

Sun base and water sparkles

Loons and their reflections

Sky/water background

Fog

Wave movements

Lighter grass highlights

Foreground bank

W. Bickford

COLOR MIXTURES

Sky/water background; distant trees; distant tree trunks;
wave movements; sun base color and water sparkles;
sun aura (corona) and water sparkles; foreground bank;
fog; lighter grass highlights; loons and their reflections

1 Begin the Misty Background

Use the mister bottle to lightly dampen the entire canvas surface. Liberally apply gesso to the entire canvas using the wash brush.

Create a purplish base color with white, some blue and equal touches of red and sienna. Make sure to mix enough to fill the entire canvas. While the canvas is still slightly damp, cover it with an even coat of the misty basetone using broad crisscross strokes. Strive for a middle value—not too light and not too dark—because the trees, loons and foreground bank will eventually be darker than this color. Wipe the brush and blend to a smooth finish to minimize any brush marks. If needed, dip your brush in water to facilitate the flow of paint over the large area.

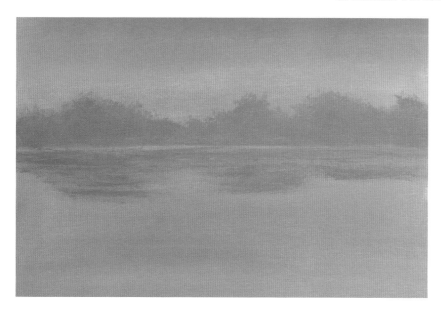

2 Establish the Horizon and Distant Treeline

Using a pencil, establish the horizon line just above the center of the canvas, drawing through the wet paint. On your palette, darken the mixture from step 1 by adding a little more blue, red and a touch of sienna. Make sure you have enough to use in the next few steps. Reestablish the horizon line with the edge of the no. 3 fan, pressing the bristles horizontally to the canvas.

Add a bit of the dark mixture to the corner of the brush and render the background's wispy treeline with light, circular, scrubbing strokes (see page 23 for the "Spiky Bristles" brush technique). The canvas is a little wet, so it's not a true dry-brush technique, but it's somewhat similar. Vary the heights and shapes of the treeline to keep it interesting and natural. Fill this color upward from the reestablished horizon line.

Using the same mixture and brush, gently scuff in horizontal strokes to suggest tree reflections in the water, just below the horizon. Strive for a back and forth brushstroke motion to work the paint into the water. There is no need to overdo it, especially in this foggy atmosphere. Simply suggest the treeline's reflection. Let the painting dry completely.

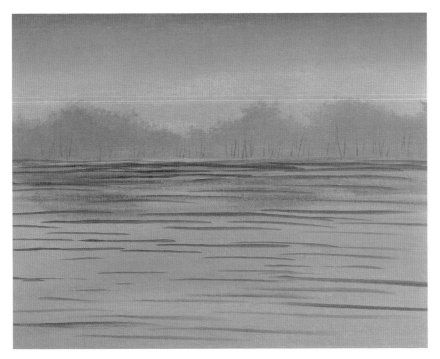

3 Add the Wave Lines

Add a few wave lines with the no. 10 bright. Add a touch more blue and a speck each of red and sienna to the basetone from step 2 to achieve a slightly darker value. Load the brush to a sharp, chiseled edge and create some random horizontal movements in the water. Make sure to overlap the tree's reflections with a few waves. Remember, more lines indicate more movement, and fewer lines suggest calmer water. This is your choice.

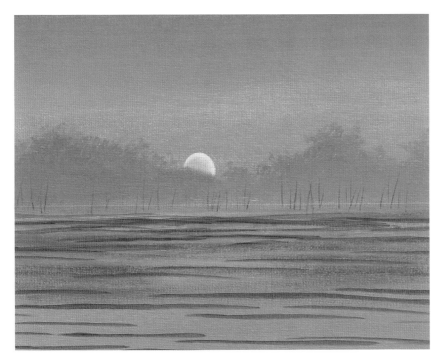

4 Add the Sun and Water Sparkles

Create a reddish orange mixture of mostly white, some yellow and a touch of red for the glowing sun. This is the same mixture you will use for the water sparkles, so make sure to mix enough. Carefully paint the sun's round shape with a no. 2 round. Wipe the brush and blend lightly where the sun meets the top of the treeline to create a soft edge and give the illusion that the sun is sinking behind the trees.

Wipe the brush and use a mixture of mostly white and a touch of yellow to add the bright *corona* (set of white circles usually seen around a luminous body such as the sun or moon) around the outside top edge. This will add warmth and visual interest to the sun, more so than using one solid color.

Use a Coin to Trace the Sun

Take a small coin and trace around the edge using a pencil to create a round circle for the sun. Work within the scale of the painting and make the sun no larger than ¾" (19mm).

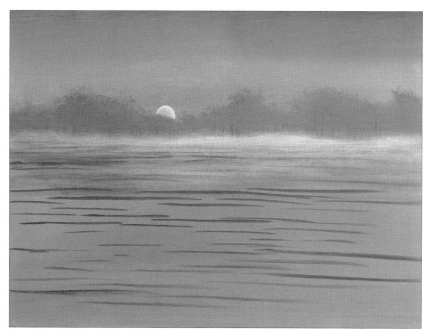

5 Render the Shoreline Mist

Use the no. 3 fan and white thinned with water to make the shoreline appear translucent. Load the brush and wipe it with a paper towel so you pick up very little paint. Use the end of the bristles and brush lightly at the horizon level to create a hazy, misty feel at the shoreline. If you apply too much paint or make it too heavy, take a slightly damp paper towel and wipe off some of the white. Brush downward over the water as far as you would like the mist to extend.

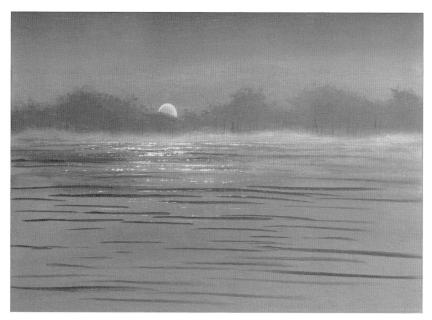

6 Add the Water Sparkles

Create sparkles on the water's surface using the sun's basetone from step 4. Load a thin sliver of the orange hue on the long edge of the painting knife and drag it horizontally across the canvas, beginning at the horizon and working downward. Create a few sparkles with the sun's yellow highlight color (from step 4). Keep these shimmers more dominant in the area around the sun and its reflection. This area represents the focal point of your painting and will draw the viewer's eye.

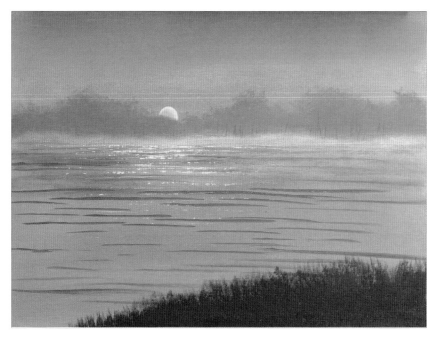

7 Create the Foreground Bank

The foreground bank and loons are in silhouette, so they will be rendered using a simple dark value, the darkest in the painting. Mix a dark, bluish-gray color for the foreground bank and loons with mostly blue, some sienna and a little red. Tap a slightly damp wash brush into the mixture, loading the ends of the bristles to a spiky configuration. Form the ragged edge of the bank using the same tapping motion, tapering the bank toward the bottom of the canvas from right to left. Fill in this land area solidly, maintaining a down-ward, dabbing stroke to achieve the grassy texture. (See the "Horizontal Chiseled Edge" brush technique on page 23 for a visual.)

8 Render the Cattails and Grass Blades

With the script liner, add the longer, individual blades of grass using the grass value from the previous step. Thin the dark paint with water to achieve long, slender lines. Drag the brush through the palette while rolling it through your fingers to fully load the brush. Continue adding a little water to the paint mixture to keep it fluid, since the dry canvas will draw water from the brush. Refer to the "Grass Clumps" exercise on page 61 for tips on how to pull natural, tapered grass.

Create cattails by pulling a long stem from top to bottom. Lay the bristles flat in the paint to load the brush, then flatten the bristles and pull the brush downward on the canvas to create the end of the cattail (*flower spike*). Use both sides of the brush to ensure that enough paint is transferred to the canvas.

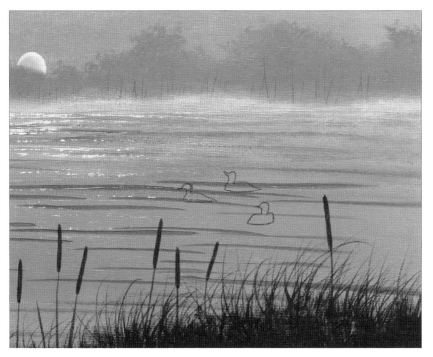

9 Transfer the Loons Sketch

Let the painting dry completely before adding the loons. Use graphite paper to transfer the sketch, making sure not to position them in the dead center of the painting. Since they are backlit, they will be painted with one dark value and no highlights.

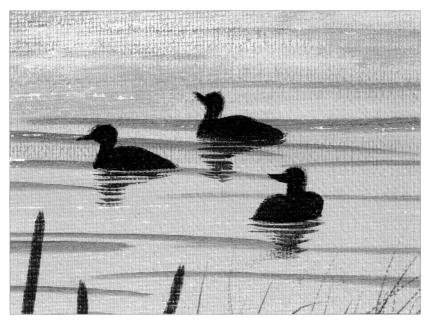

10 Block In the Loons and Reflections

Carefully paint in the loon shape using the script liner and the thin, dark value used for the grass blades in step 8. Using a brush that is loaded too fully will make it difficult to control and will thus render imprecise shapes. Roll the bristles through the paint, bringing the brush to a point, then touch the brush tip to a paper towel to remove excess paint.

Reflections will connect the birds with the water and anchor them in the landscape. With a script liner and the dark mixture used in this step, create thin, horizontal lines beneath each loon to suggest the movement and reflections of the loons on the water's surface. Wipe the brush, and drybrush the reflections to gently blend them into the water.

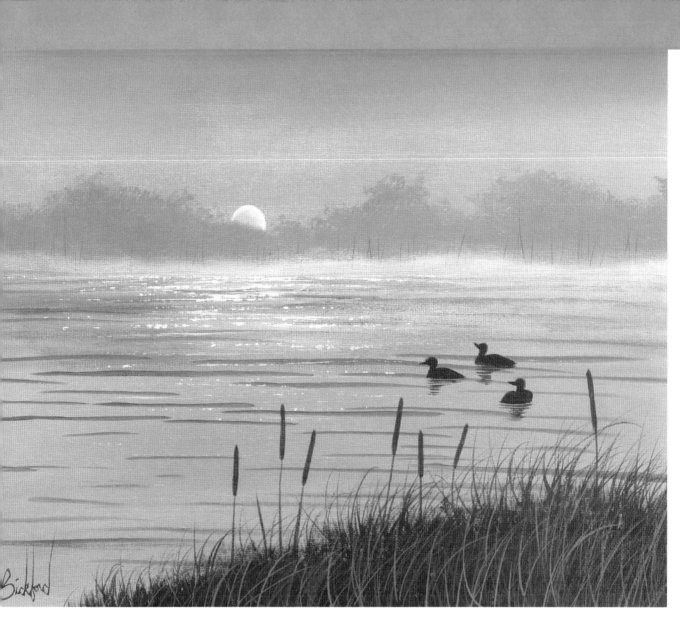

Loons on the Lake
Acrylic on canvas panel board
12" × 16" (30cm × 41cm)

11 Add the Finishing Details

As always, look over your painting and decide what improvements can be made. Do the sun sparkles stand out as they should? A brighter orange or yellow can easily be added. Is more texture needed in the grass? Again, that's an easy adjustment. Remember that a painting must be viewed as a whole, so the necessary tweaking might not be evident until the end when everything is in place. This doesn't mean that you made mistakes along the way, only that an adjustment or two might improve your finished piece.

I pulled some long, light-colored grass blades from bottom to top to create subtle depth in the foreground. To do this, add a bit of white to the dark grasstone from step 8, thinned with a little water.

Mallard ducks are plentiful in my area and inhabit most of the lakes and swamps in the vicinity. They have colorful feathers of iridescent greens and deep oranges, and move swiftly in flight. While females are not as vibrantly colored as males, they have beautiful markings. Mallards primarily eat vegetation, but also consume small fish and insects.

My neighbor has a small pond that beckons ducks, geese and occasionally a swan or two. Since the pond is located a short distance down the road, I often hear the honks and quacks as the birds flap and splash in the water. My wife Glenda and I pass their little oasis on our evening walks. We often slow the pace for a few moments to observe them more intently.

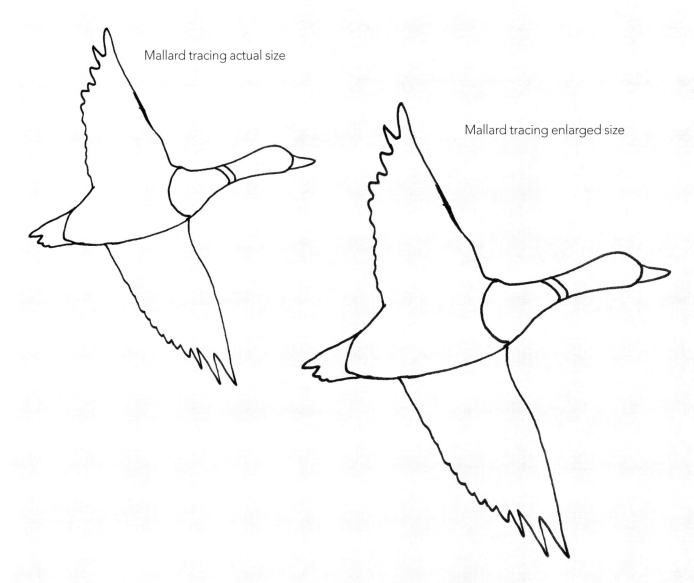

Mallard tracing actual size

Mallard tracing enlarged size

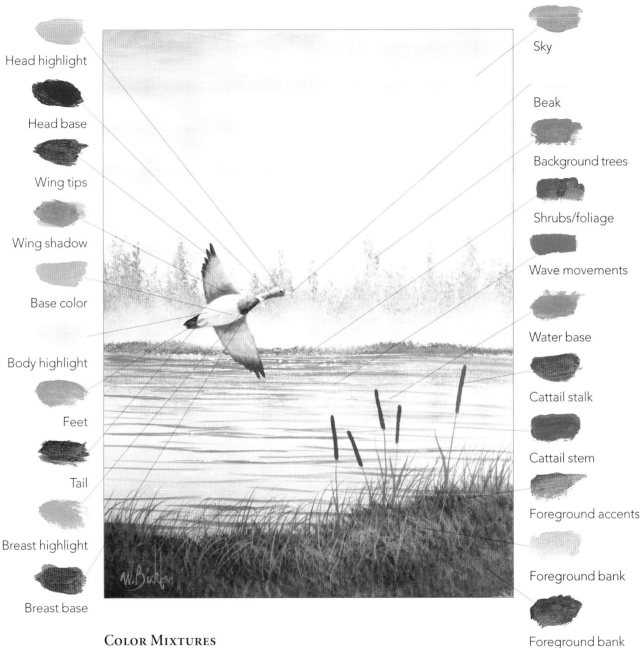

Head highlight

Head base

Wing tips

Wing shadow

Base color

Body highlight

Feet

Tail

Breast highlight

Breast base

Sky

Beak

Background trees

Shrubs/foliage

Wave movements

Water base

Cattail stalk

Cattail stem

Foreground accents

Foreground bank

Foreground bank

Color Mixtures

Background trees; shrubs and foliage; water base color; wave movements; water sparkles (white); foreground bank (dark value); foreground bank (light value); foreground bank grass; foreground accents; cattail stems; cattail stalks/spikes; mallard (base color, wing shadow, body highlight [white], wingtips, head basetone, head highlight, neck ring [white], breast basetone, breast highlight, beak, tail and feet)

1 Begin the Background

Using a pencil, mark a reference for the horizon just below the center of the canvas. Lightly dampen the sky area with a mister bottle and apply an even coat of gesso to the upper canvas with a wash brush.

Create an overcast look using a purplish mixture of mostly blue and a touch of red. If you want to achieve a grayish stormy sky add a touch of sienna to mute the tone. Make quick crisscross strokes using both sides of the brush and adjust the sky values to suit your taste. Move the brush horizontally across the canvas to create a dull, grayish purple hue.

With a randomly light scrubbing stroke, apply more of the mixture to the sky area, working the brush across and down the canvas in a quivering motion. Leave some areas untouched to suggest depth and clouds. A solid color can be flat and uninteresting, so try to leave value variations. Wipe the brush and use broad X-strokes with a light touch to soften the whole sky. As you pick up more paint, keep wiping the brush as needed.

2 Render the Distant Treeline

Paint in the distant treeline while the sky area is still wet. This will yield softer edges in the background and lend more depth. Use the no. 3 fan and mix some blue and a dab of yellow into the sky tint from step 1, adding a touch more blue and some yellow to create a muted grayish green. Tap the bristles of the brush into the palette to spike them, grip the brush vertically then tap across and above the horizon line to suggest pine trees. Aim for an irregular outline, with highs and lows, to create taller trees and shorter trees. Bring this color down almost to the horizon line. While this layer is wet, quickly wipe the brush and add a little white to it.

Using the brush horizontally, tap and mix this white into the base of the trees, just above the shoreline. (You may need to wipe the brush occasionally to avoid picking up too much of the green color.) Work from the water line upward, blending lighter as you go, to create a misty appearance at the water's edge. Use more white toward the focal area where the mallard will be placed.

3 Add the Shoreline

Add a bit more blue and yellow to the dirty fan brush from step 2 and tap in a darker green value on the shoreline just above the water. Hold the brush horizontally and dab slightly downward with the tips of the bristles to create rough foliage. Use the same brush with the green value and tap in a touch of sienna to add colorful variety to the shore. Note how this creates another layer of grass.

4 Begin the Water

The water section is a large blended area much like the sky, so paint it following almost the same procedure. Dampen the lower half of the canvas with the mister, apply gesso and cover it with the same grayish purple sky mixture used in step 1. Lay the color in back and forth in a horizontal direction. Begin at the base of the canvas and paint the grayish blue value right up to the shoreline, achieving a lighter value as you work higher. Variety in tone is desirable, so don't feel you have to blend it all to a solid value. That's boring!

5 Render the Distant Treeline's Reflections

While this area is still damp, use the pine tree color from step 2 on the no. 3 fan to create the impression of tree reflections. Load the brush to a chiseled edge, and scuff back and forth in a horizontal direction (see the "Horizontal Chiseled Edge" brush technique on page 23). Render the reflections somewhat blurry to indicate movement of the water surface.

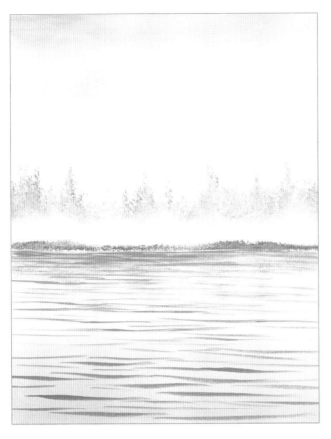

6 Create the Wave Lines

Create a darker green mix of the water base color from step 4 by adding a little more blue, a touch of red and a tiny speck of sienna. With the no. 10 bright, scuff in wave lines to give the water the appearance of motion. Load the brush to a sharp, chiseled edge by matting it on both sides against the palette, and use horizontal strokes to suggest wave action. Hold the tip of the brush on the canvas and scuff horizontal wave lines across the canvas, varying the amount of paint on the brush and the amount of pressure to create larger and smaller lines. Work below the reflections and try to keep the lines darker and more distinct near the bottom of the pond, and use less paint as you work up toward the shoreline. Vary the length and spacing of the lines. For rougher water, add more lines; for a calmer surface, add fewer lines.

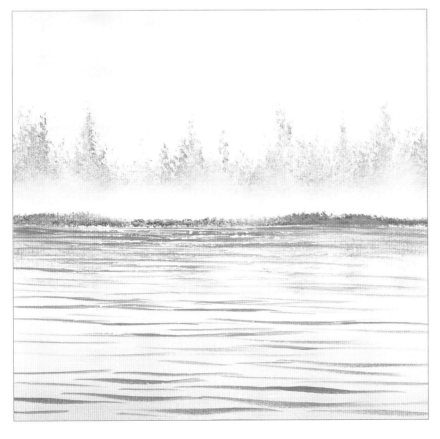

7 Add the Water Sparkles

Cut in sparkles on the water surface using a thin ribbon of white on the long edge of the painting knife. To load the painting knife, pull a thin layer of white across your palette using the flat part of the blade. Wipe the blade clean, then drag the long edge of the knife through the white, picking up a sliver of paint on the edge. Work horizontally with a dab and drag motion to create shimmering water lines. Add sparkles as desired, but concentrate them more toward the middle of the painting and shoreline and away from the edges to guide the viewer's eye to the center where the mallard will be placed.

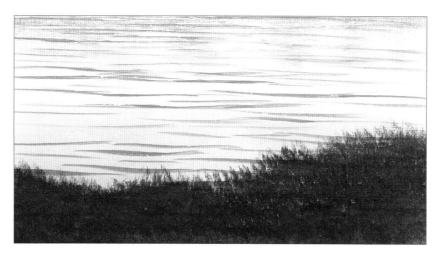

8 Establish the Foreground

Create a dark-green mixture from blue, a touch of yellow and a bit of sienna to establish the foreground land. The wash brush is great for creating textures, but should be loaded differently for painting foregrounds than it is for painting backgrounds. Load your color on the brush, wiping any excess paint on a towel. Pounce the bristles lightly in the paint mixture on the palette to spike the bristles. Using a light pouncing motion, dab a solid coat onto the bottom of the canvas to create the closer landmass. Fill in the entire area with your dark value, aiming for a grassy, textured look across the top of the foreground.

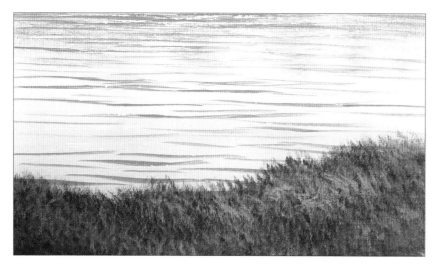

9 Render the Foreground Highlights

Add a bit of yellow and a touch of white to the dirty wash brush and create highlights with the same pouncing motion used in step 8. Leave some of the dark color peeking through the lighter hues to give the grass depth. Try dabbing in a little sienna randomly, or vary the amounts of white and yellow throughout the foreground to add visual appeal.

Careful Not to Overload It

If your brush gets overloaded with paint, you may need to wipe it off with a damp paper towel to achieve the spiky bristle effect.

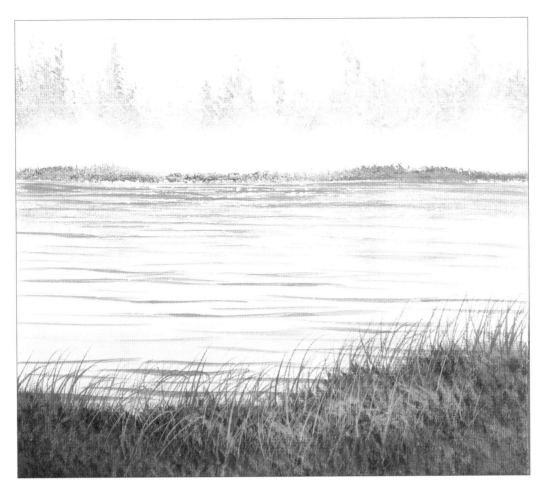

10 Pull Out Tall Grass Blades

Thin the grass colors from steps 8 and 9 with a little water and use the script liner to further define the bank with individual grass blades. Roll the brush handle between your fingers to load it full of the juicy paint mixture. Pull the strokes from the bottom of the foreground up, letting the grasses lean to-and-fro. Using just the tip of the brush on the canvas will yield more slender grass blades.

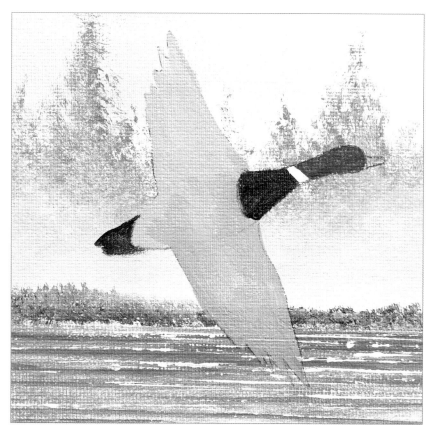

11 Transfer the Sketch and Block In the Main Values

When the painting is completely dry, transfer the sketch using your graphite paper. Refer to the finished painting on page 95 for approximate placement.

Block in the head, breast, body, neck ring and tail in this order (see chart on the facing page for mixtures). The mallard's main base colors are, for the most part, divided into sections and don't need to be blended into each other. The larger masses can simply be blocked in using the script liner brush. Dab in the base colors with the no. 2 round, cleaning the brush between each color application.

Painting a Mallard

The duck is comprised of several colors, but we will break them down into separate sections to simplify the process. You can use the no. 2 round for most of the mallard, though the liner brush may be more suitable for the smaller sections (beak, wingtips, feet). Use the brush that's most comfortable for you. Always remember to thin the paint with water to help the paint flow, making the application easier.

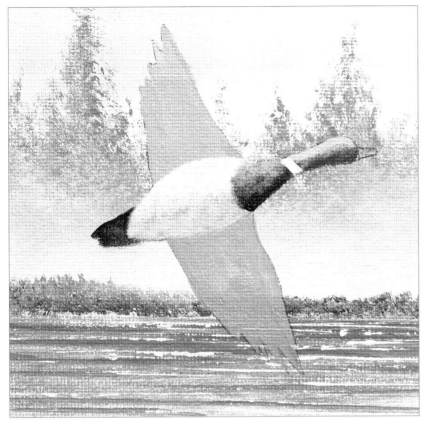

12 Render the Wing Texture

Dab in the colors with the tip of the no. 2 round or liner to achieve a slightly textured look suggesting feathers and fluffy highlights, (see chart below for highlight mixtures). You may find it necessary to add a second coat of paint to these areas after your first highlights dry to ensure that they are bright enough.

Basetones

Head – a bluish green made up of mostly blue, some yellow and a touch of white

Head highlight – add a touch of white and a speck of yellow to the head color

Breast – sienna (pure)

Breast highlight – add a touch of white to the breast base color

Body – a light off-white made from mostly white, a touch of sienna and a speck of blue

Body highlight – mostly white (pure) with a touch of the body base color

Features

Tail – a black made from equal amounts of blue and sienna with a touch of red (no highlights for the tail)

Neck ring – white (pure)

Wings – a slightly darker mixture of the body color, created by adding a touch more sienna and blue

Wing shadow color – add a lot of white to the wing color

Wingtips – a darker mix of the wing color, created by adding sienna and a touch of blue

Feet – an orange derived by mixing yellow, a small amount of red and a touch of white

Eye – use the dark wingtip value

Beak – yellow with a touch of white on liner (you can also add a speck of red to this tone for the feet)

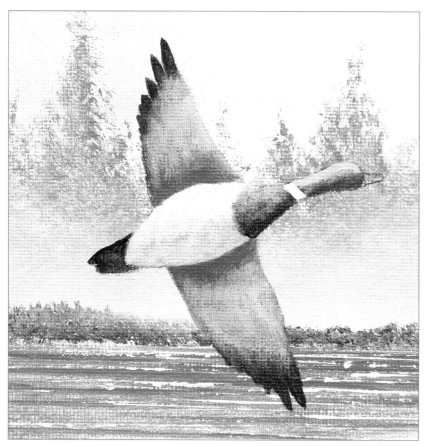

13 Darken the Wings and Add the Shadows

Add another coat of the wing basetone from step 12 to the wings' undersides until they have an even tone. Add a touch of white to this basetone to create a lighter shadow color, then accent the middle part of the wings with a clean round brush. Make sure to work from the mallard's body toward the wingtips, so you have a clear stopping point.

Define the wingtips with a darker version of the wing color (see chart on page 93 for mixture), and pull a pointed round or liner from the tip into the wing towards the body. This will give each wingtip a sharper edge. Blend each wing's basetone and shadows together by gently drybrushing. Rotate the canvas to an upside-down position or one that's comfortable for you to paint the other wing's tips.

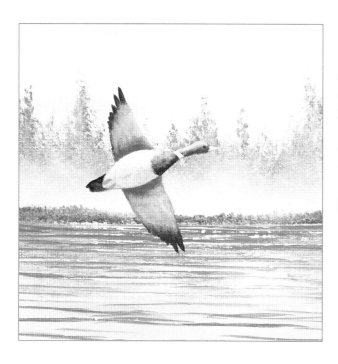

14 Paint the Feet, Beak and Eye

For the feet, roll the round or liner in paint (see chart on page 93 for all mixture) and dab it once on the canvas to create each foot. Exact detail is not necessary since the mallard is shown in the distance.

Gently paint the beak using the liner brush brought to a fine point. To paint the eye, use a dot of paint with the dark wingtip value from step 13.

Highlight the top of the body directly behind the breast with a touch of white to make the upper body pop.

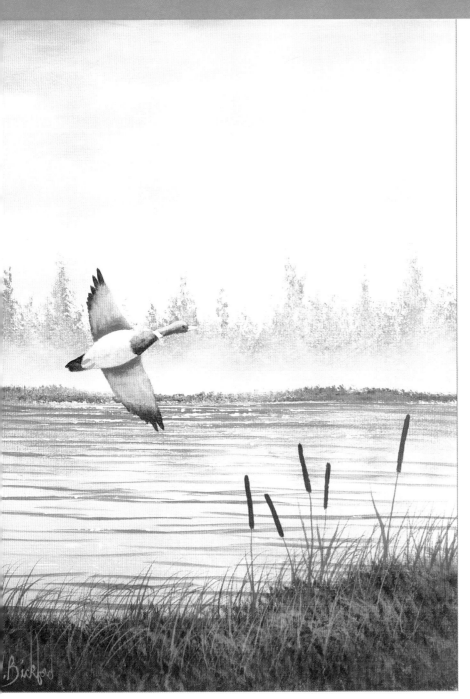

15 Add the Finishing Details

Check your contrasts and make any needed adjustments. Are you pleased with your results? Be patient. Painting is a skill that improves with much practice. Don't be afraid to try this project again. Experiment with your color mixtures to attain different moods.

I added a little more fog with a no. 2 round around the shoreline near the mallard. Wipe the brush with a damp paper towel and gently drybrush the paint into the foggy white of the treeline to draw attention to the center point of your landscape: the mallard.

I also added some cattails using the foreground base color from step 8. See page 81 for detailed instruction on painting cattails. Use a clean liner brush and a new mixture for the flower spike of mostly sienna and equal specks of blue and white. Try to paint an odd number of cattails—the human eye tends toward perfection, whether in perfect spacing or perfect pairs. Odd numbers of objects, randomly placed, work best.

Marsh Landing
Acrylic on canvas panel board
16" × 12" (41cm × 30cm)

Is there anything more awe-inspiring and majestic than a bald eagle in flight? It is the epitome of power, grace and strength. Though bald eagles are more prevalent in the western U.S., I occasionally see them patrolling the mountain lakes and streams in upstate New York. Our local zoo has a pair of these magnificent birds of prey on display, and though I have mixed feelings regarding their captivity, it does provide us the chance to study them closely. The bald eagle population in the U.S. has declined drastically over the past fifty years because of pesticides and hunting, among other reasons, but fortunately, they have made a comeback in the wild and have been removed from the endangered species list.

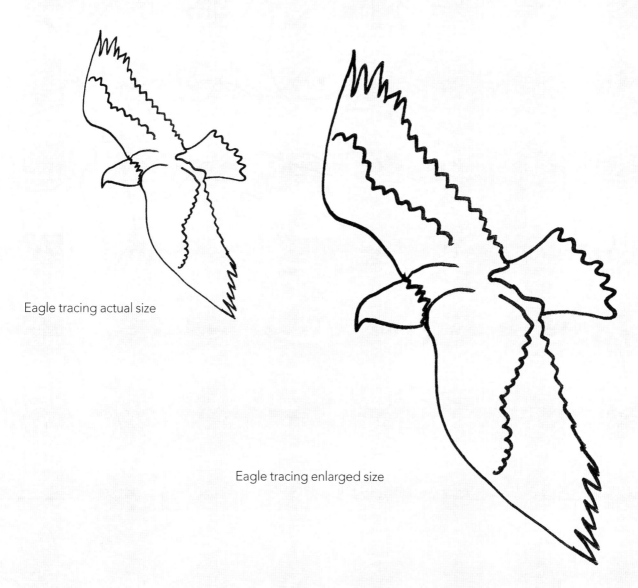

Eagle tracing actual size

Eagle tracing enlarged size

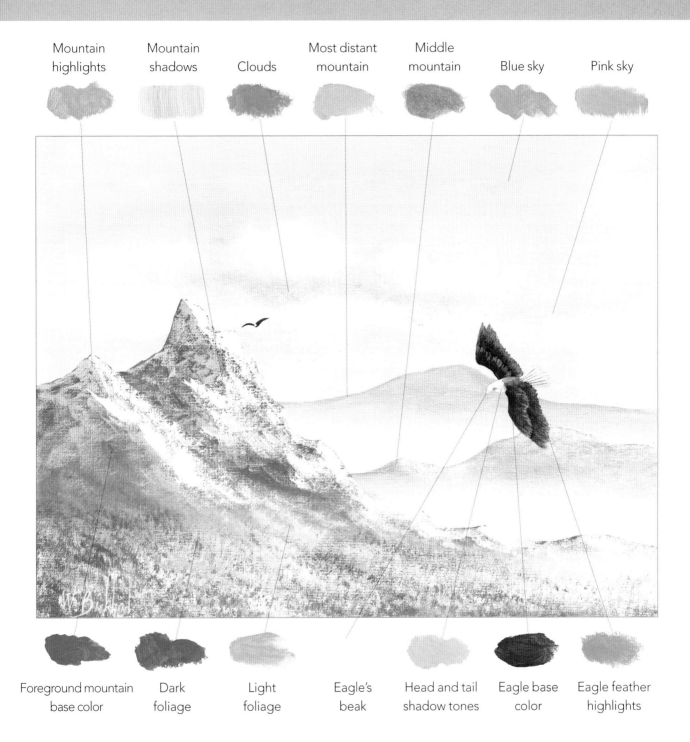

Mountain highlights

Mountain shadows

Clouds

Most distant mountain

Middle mountain

Blue sky

Pink sky

Foreground mountain base color

Dark foliage

Light foliage

Eagle's beak

Head and tail shadow tones

Eagle base color

Eagle feather highlights

COLOR MIXTURES

Pink sky tone, blue sky tone, clouds, distant mountain, middle mountain, foreground mountain, mountain highlights (light pink, then white), mountain shadows, dark foliage, light foliage, eagle (base color, feather highlights, white head/tail shadow tone, head and tail highlights, and beak)

1 Begin the Background

Dampen the entire canvas with a light mist from the spray bottle. Using the wash brush, generously cover the canvas with an even coat of gesso. This will help create the gradual fade into mist in the lower right corner of the canvas. Notice that there is no distinct line where land and sky meet because of the mist between the mountain ranges. Rather, the foreground and background will be established with the outline of the distant mountain.

Work a small amount of red into the gesso on the brush and establish a pinkish band of color through the middle of the canvas. Adjust the tint to suit your taste, lighter with more white or darker with more red. Once the pink value is established, immediately wipe the brush thoroughly on a towel, and use fast, crisscross X-strokes to blend the pink tone into the white basecoat, dissolving any edges.

Working quickly, wipe the brush on a damp paper towel and pick up a little blue on the same brush to create a darker tone in the top sky area, working across and downward. Wipe the brush and, using the same blending approach as with the pink tone, gently bring the blue and pink tones together, melting them into each other. Strive for a gradual transition.

2 Add the Cloud Basetone

Create a grayish cloud color by adding a small amount of blue and a touch of sienna to the blue sky color. You can also add a touch of white if you think the tone is too dark. Using the corner of the no. 3 fan, make gentle, circular strokes in a horizontal motion to create wispy clouds that will eventually fade behind the mountains. It is a similar brush technique to the one used to create distant foliage.

3 Render the Cloud Highlights

Rinse the no. 3 fan when the clouds are painted to your liking and add a touch of pure white. Create a fluffy, billowy edge on the tops of the grayish clouds with quick, short, up-and-down motions on the corner of the fan. Wipe the brush on a paper towel and drybrush the white into the grayish cloud color to blend in strong upper highlights. It's important to maintain enough gray underneath to retain the clouds' depth.

4 Begin the Distant Mountain Silhouette

While this area is still wet, form the most distant mountain's silhouette and fade its base into the mist. Add a little white and a touch of blue to the grayish cloud base from step 2. The tint works well to suggest distance. Use a no. 10 bright create the shape of the range. Concentrate on achieving a natural flow of the land—no pyramids!

Establish the outline across the canvas, then pull the color down to a somewhat even level. Add a touch of white to help the color fade and transition into the next mountain range. Wipe the brush, then blend the color into the lower-middle part of the canvas. Leave the bottom third of the canvas untouched and white.

The entire sky and background area requires extensive blending and you will find that working quickly will ease the process.

5 Create the Middle Mountain Silhouette

Use the distant mountain's value from step 4 and add touches of blue and sienna. The darker value will help it pop in the foreground. With the no. 10 bright, drag the shape of the middle (closer) silhouetted mountain, making sure not to place it directly underneath (or identical in appearance to) the distant mountain. Bring it down to an even level and add a little white to the brush to help it fade into the bottom of the canvas. Use horizontal, back and forth strokes and drybrush with a crisscross motion to blend the tone into the white bottom of the canvas.

The Palette vs. Your Canvas

Your pink sky base color will appear darker on your palette and brush, but will be lighter on the canvas when mixed with the gesso. This is OK!

6 Render the Large Foreground Mountain

The large foreground mountain is a darker value than the distant two. Mix some blue and white with a touch of sienna. The value is much more critical than the color—it needs to be darker than the middle silhouetted mountain. Any form of gray, blue-gray or brownish gray will be fine, but it must be darker in contrast against the overall background.

Create the mountain shape with a no. 10 bright, beginning with the tallest apex and taking care to achieve an appealing contour.

Make sure all peaks are spaced out and are at different heights. Paint the mountain shape completely, all the way to the canvas bottom. It helps to think in terms of a main summit, and one or two secondary peaks. Brushstrokes are not critical because the mountain will be covered with highlights. Strive for good overall shapes.

Wipe the brush, load it with a bit of white and blend the mountain to the bottom of the canvas with quick crisscross strokes, (the same technique used for the silhouetted mountains). Don't strive for a perfect blend because most of it will eventually be covered.

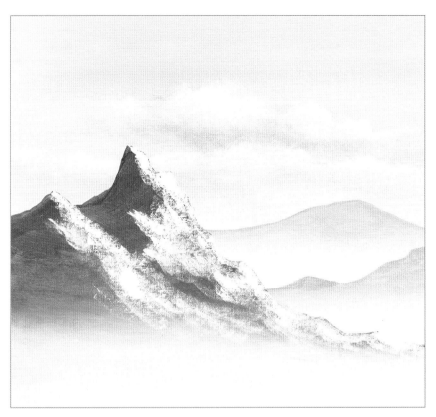

7 Establish the Mountain's Highlights

Define and highlight the foreground mountains according to where the light source is approaching. Since it is coming from the right, it leaves shadows
on the left. The sunlit snow is mostly white with a speck of red to mimic the sky color. Visualize and plan the planes of the mountain before you begin. Start at the top of each peak and work downward, creating the divisions between light and dark.

Dab and drag the pink highlight tones over the right sides of the mountains (see the caption below for a visual and more instruction). Do not fill the mountain in solidly. Leave much of the tooth and texture of the canvas showing because they will strongly influence the finished look of the painting.

Rinse the brush with water, and using the same approach, add white highlights on top of the pinkish snow reflections.

Mountain Highlights Brush Technique
Load a no. 10 bright with the highlight value, and hold it in an overhand grip nearly flat against the canvas. Dab and drag down the mountain slopes using very light pressure. Make sure to allow the darker basetone to peak through to suggest the craggy surfaces and depressions of the mountain's surface.

8 Render the Shadows

Establish the shadows on the left side of the mountain as you did for the pink and white highlight tints of snow in step 7. Create a bluish gray mixture of white, blue and a touch of sienna. (A speck of red will add a purplish tint.) Again, make sure to let the undertone show through. Hard edges between the snow shadows and the pinkish reflections will suggest a crest or snowdrift and give the mountain a sharp, three-dimensional look.

If you can't achieve this sharp edge, wipe your bright brush to a chiseled edge and use a heavier touch to create a more defined line between the two planes.

Wipe your brush with a damp paper towel and dry-brush the lowermost pink tones into the dark bottom of the mountain using crisscross strokes.

9 Establish the Foliage

Render the treeline and foliage at the base of the mountain with a no. 3 fan and a thick green mixture of blue, yellow, some sienna and a touch of white. Tap the bristles into the paint on your palette, spreading them to a spiky point. Beginning at the bottom of the canvas, tap texture onto the mountain working up the slopes. Use less paint and a lighter touch as you work higher, allowing the foliage to recede and become less distinct. Turn the brush at varying angles as you work. Similar to the mountain's snow, it is more interesting if some of the canvas is left visible. Leave some of the grayish white base color showing though, leaving the impression of snow. A lot of detail is not necessary for the foliage, so don't overwork it.

Add a fair amount of white and a touch of yellow to the dirty brush to mix a yellowish green tint. Using the same tapping motion as for the darker green value, tap the lighter value to highlight the mountain brush.

Fix Mistakes With a Damp Brush

A slightly damp brush, such as a no. 10 bright, will help smudge out mistakes when you're working in tight, detailed areas. Otherwise, use a damp paper towel to wipe out errors.

10 Transfer the Eagle and Block In the Main Tones

When your painting is completely dry, transfer the eagle with graphite paper, using the finished painting on page 105 as an approximate guide for placement. Keep the eagle's lower wing in the vicinity of the misty area.

Create the eagle's body and wing base color with a dark-brown mix of mostly sienna and a touch of blue. Block in the color with the no. 2 round or liner. Pull gently from the wingtip inward for a ruffled feather look.

Create the base color for the bird's head and tail with a gray-violet mixture comprised of white, a little blue, and a touch each of sienna and red and use the no. 2 round to block in the colors.

11 Establish the Individual Feather and Body Forms

Using white and a no. 2 round, highlight the top sides of the head and tail to lend shape and form to the large body masses. Wipe your brush and gently drybrush the white to blend the bottom edges into the shadow tone to suggest three-dimensional body roundness.

Slightly darken the value of the head and tail with a touch more blue and sienna. Use the script liner to separate individual feathers by placing a shadow line of the gray mixture between each feather. Place a dot to indicate the shadowed eye socket. Rinse the liner brush and use a touch of yellow to carefully paint the beak. Darken or lighten the yellow beak value depending on the level of contrast between the eagle and the background mountain.

12 Add the Highlights

Add white to the eagle's base color from step 10 and use a no. 2 round to highlight and define the rows of feathers on the wings. Work from the tips of the feathers toward the head to yield a sharp, crisp edge on each feather. Define the rows, not the individual feathers, and leave the dark base color exposed between the feathers and rows. This color is also used to contour the eagle's back, from head to tail. Wipe your brush on a paper towel and drybrush the lower edges of the highlights against the dark to soften the base color and add roundness.

13 **Add the Finishing Details**
Add a small amount of white to the pink mountain highlight color from step 7. With the same downward motion described in the "Mountain Highlights" brush technique on page 101, pull the loaded brush gently down the edge of the slope to add soft, light highlights. When dry, you can rehighlight with a little more white or sienna to keep the colors bright.

Look over your painting and make any necessary value adjustments by lightening and darkening highlights and contrasts. Now you're soaring with the eagles!

On the Wing
Acrylic on canvas panel board
12" × 16" (30cm × 41cm)

Add a Distant Eagle
Take some of the eagle base tone from step 10. Near the foreground mountain's summit, paint in the basic shape of a distant eagle as a simple, flattened V-shape. Place a bit of watered-down pure white on the fine point of the liner brush and dab in a white mark for the distant eagle's head. Make sure you make him tiny enough to appear far off in the sky.

If you've ever seen one of these beautiful waterbirds floating along the surface of a calm lake or pond, you know why they are often described with words like "graceful" and "majestic." Swans are one of the larger species of the goose family and they tend to mate for life. Though I encounter these birds less frequently than the geese and ducks I've mentioned, they do visit nearby ponds on occasion. Once, I was conducting a plein air class at a very picturesque location known for its ponds and willow trees. Our painting group had the good fortune to observe a pair of swans easing through the ripples. At the time, I did not have my camera with me, but I returned later to snap a few reference photos. They will come in handy for many future paintings.

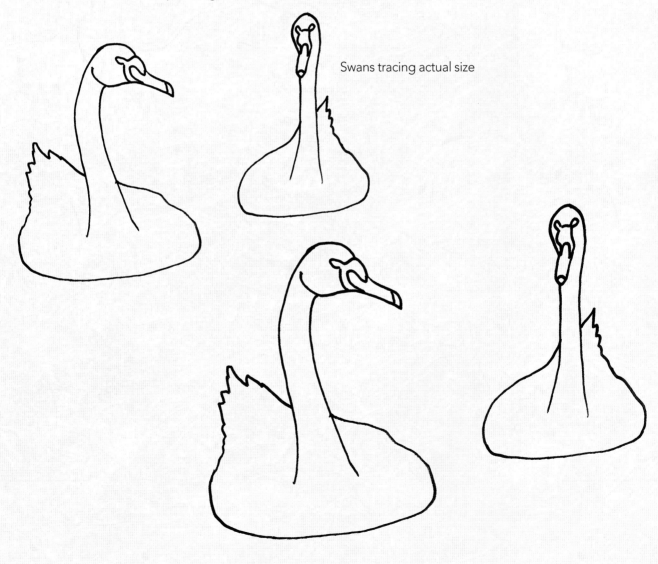

Swans tracing actual size

Swans tracing enlarged size

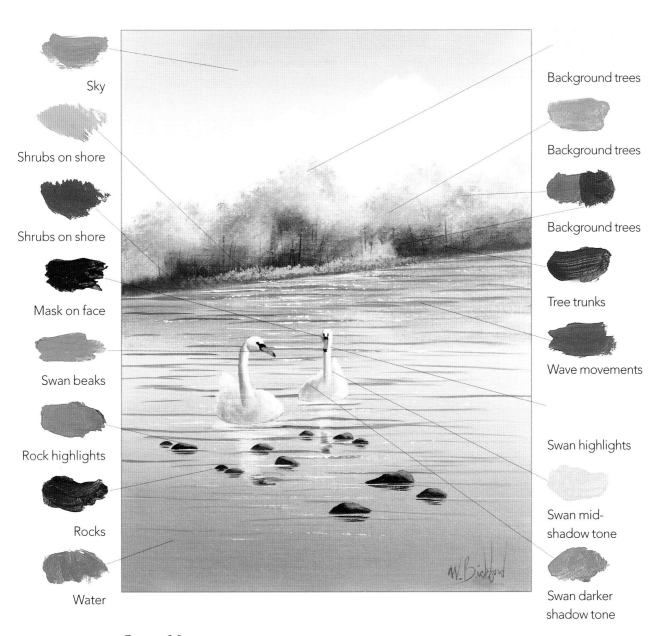

Sky

Shrubs on shore

Shrubs on shore

Mask on face

Swan beaks

Rock highlights

Rocks

Water

Background trees

Background trees

Background trees

Tree trunks

Wave movements

Swan highlights

Swan mid-shadow tone

Swan darker shadow tone

COLOR MIXTURES

Sky, background tree values, tree trunks, shrubs on shore, water, wave movements, water sparkles (white), rocks, rock highlight, swan (shadow midtone, darker shadow tone, highlights, beaks, mask on face)

1 Begin the Background

Sketch the horizon line with your pencil. Place it slightly higher than the center on the right and lower than the center on the left. Lightly spritz the upper canvas with the mister bottle and apply a generous, even coat of gesso with the wash brush. Create the sky color with a mixture of mostly blue and a speck of sienna, which grays it slightly. Paint the sky using light-pressure crisscross strokes. Start at the top of the canvas and continue toward the horizon using a lighter pressure as you work down. Strive to minimize any brush texture.

2 Render the Clouds

While the sky area is still wet, add white to a clean no. 3 fan and scrub in a few horizontal cloud movements. Create wispy strokes of white to add puffiness and depth to the sky. Use circular scrubbing motions with the corner of the fan brush, fading the white down into the blue of the sky.

3 Create the Trees

Follow the "Group of Deciduous Trees" exercise on page 57 for this step. You will need to create three different values for the leaves of the autumn trees. Begin with the darkest tone. First, create a dark-reddish mixture with sienna, white and a touch of red. Take a bit of the reddish mixture on the edge of the no. 3 fan and paint the leaves with light, circular strokes.

Add sienna and a touch of blue to darken the reddish leaf value to achieve a deep, rusty tone. This color will represent the shadows at the base of the trees. With the fan brush, make circular strokes down to the water's edge and blend the rust color to the base of the reddish color.

Create a bright orange mixture with bit of white, a touch of yellow and a speck of red. Wash the fan brush, and add this color randomly using the same technique, leaving some of the original darker value showing through.

Add some highlights of mostly white and a touch of yellow using the same jittery touch with the brush. Apply the tone mainly on the tops of the trees, fading the yellow value away into the red and orange leaf colors. Too much yellow paint will hinder the multicolor effect of the trees, so wipe your brush if it begins blotching the canvas.

Lastly, create a grayish brown mixture with sienna, a little blue and a speck of white. Thin the mixture with water and add a few intermittent trunks. Use the script liner to pull thin lines upward from the shoreline into the leaves, tapering them at the top.

4 Render the Grassy Shoreline

When you are satisfied with the trees, wash the no. 3 fan then tap in the grass area with a green mixture made from white, blue, yellow and a touch of sienna. Tap the brush horizontally across the shoreline, pulling the spiky bristles slightly downward to create natural-looking shrubs. Wipe the brush with a damp paper towel and add a bit of white and touch of yellow to achieve a light-green mixture. Highlight the tops of the shrubs toward the center of the shoreline to create a focal point that leads toward the center of the landscape. Fade the highlights by using a softer touch as you work from the center out toward the edge of the canvas to emphasize the focal point.

5 Begin the Water

Use the mister bottle to dampen the water area. Use the wash brush to apply gesso from the shoreline down, as you did for the sky. Use the sky mixture from step 1 to paint in the water area completely. Start at the bottom of the canvas and work horizontally toward the shoreline, making sure to smooth out the bottoms of the green shrubs. Since this is water, the blend doesn't have to be perfect. Horizontal streaks here and there are acceptable.

While the water's base color is still damp, use the leaf values of red, brown, orange and yellow from step 3 to brush in the tree's reflections. Deposit smudges of these colors in the water using the no. 3 fan and a back and forth motion. Wipe the bristles, then drybrush and fade the reflections into the water as you work further down the canvas. Since rippling water is somewhat distorted, exactness is not necessary.

6 Add the Wave Lines

When these reflections are dry, create wave lines with the no. 10 bright. Use the water basetone from step 5, but darken it somewhat by adding a bit more blue and a tad of sienna. Load the brush to a chiseled edge and paint horizontal wave lines using the tips of the bristles. Fewer lines represent calmer water, while more lines give it more movement.

7 Paint the Water Sparkles

Create a thin puddle of white on your palette with the flat side of the painting knife. Drag the long edge of the knife through the paint to obtain just a sliver along the edge. Cut in as many horizontal shimmers and sparkles as you desire. Avoid going overboard with sparkles near the far edges of the canvas to keep the main focus in the center of the shoreline.

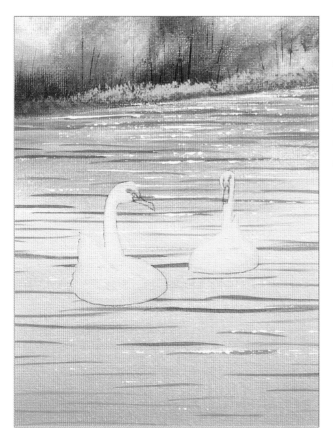

8 Transfer the Swans Sketch and Block In the Main Tone

When your canvas is completely dry, transfer the swans sketch, referring to the finished painting on page 115 for approximate placement. Use the no. 2 round to block in the heads, necks and bodies with a gray-violet mixture comprised of mostly white, a touch of blue, and a speck each of red and sienna.

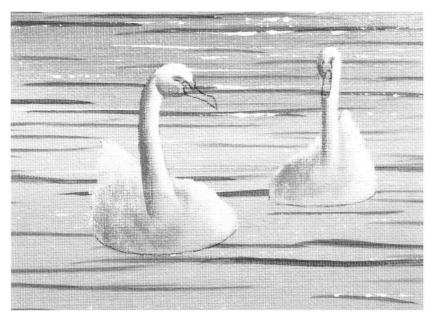

9 Establish the Highlights

Rinse the no. 2 round and use pure white to highlight the tops of the heads, sides of the necks and bodies. Note that the light source is coming from the right, so the left sides of the swans' bodies will be in shadow. Use a dabbing touch with the brush to give the swans a fluffy, feathery appearance, particularly in the tail and body areas. Repeat the white highlights after the first application is dry for a brighter appearance.

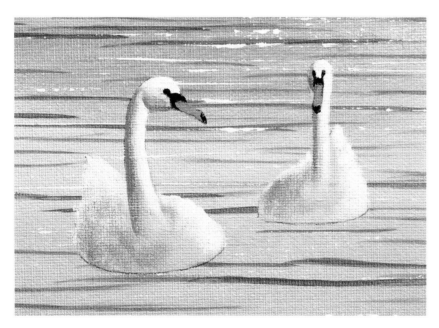

10 Paint the Eyes, Masks and Beaks

The black eye and mask sections are painted with the script liner. Mix blue, a little sienna and a speck of red to obtain this very dark value. Note that the tips of the beaks carry this value as well. Thin the paint slightly with water to make the application easier. With a clean liner and a thinned mix of yellow, a little sienna, a touch of red and some white, paint the orange beaks with careful, gentle strokes.

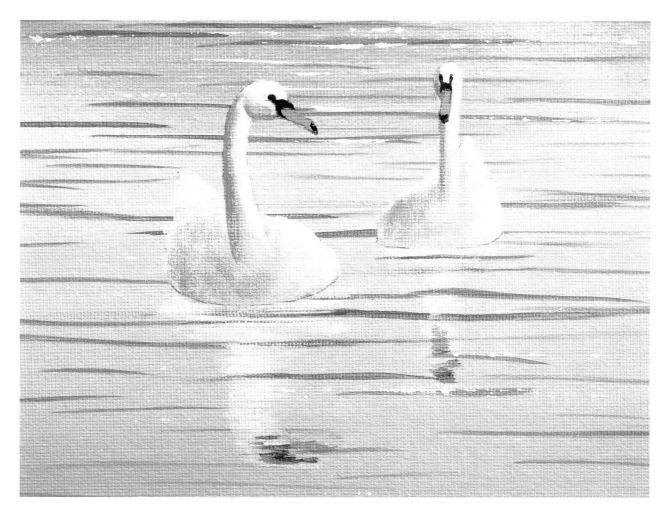

11 Render the Swans' Reflections

Suggest the swans' reflections in the water using the body base colors from step 8. Place horizontal dabs in the water with the no. 2 round to create each swan's reflective image. Dab horizontally, moving downward, being careful not to create solid figures—the water is supposed to be moving. Add the black and orange colors to the reflection with the script liner. Place more sparkles in the water as instructed in step 7. They should weave through each swan's reflection and add dimension to the water.

Rocks

EXERCISE

Rocks, both in water and on land, are great fillers for your landscapes. They come in all shapes, sizes and tones, so mix things up. Remember, "less is more" when rendering believable rocks, so avoid overworking them.

MATERIALS LIST

BRUSH
No. 2 round

COLORS
Burnt Sienna, Titanium White, Ultramarine Blue

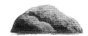

1 Create a dark-gray rock value with sienna, a touch of blue and a touch of white. Use a no. 2 round to dab in the basic outline of each rock.

2 Fill in the rock to create a flat bottom. Make sure the base of each rock creates a line parallel to the bottom of the canvas. This will anchor it into the landscape and make it appear to be sitting directly on the water.

3 Highlight the tops and sides of the rock with white using dabbing brushstrokes. Work the highlight value down into the darker rock value.

4 Thin some of the rock's base color with a few drops of water. Use the liner brush to add a few reflections under each rock with thin, horizontal brushstrokes.

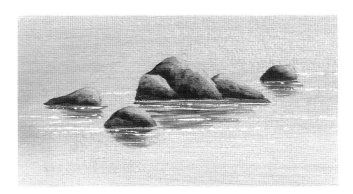

5 Create rocks on top of a body of water. Using white on the edge of a painting knife, place some sparkles in the water and under the rocks to create a shimmering effect.

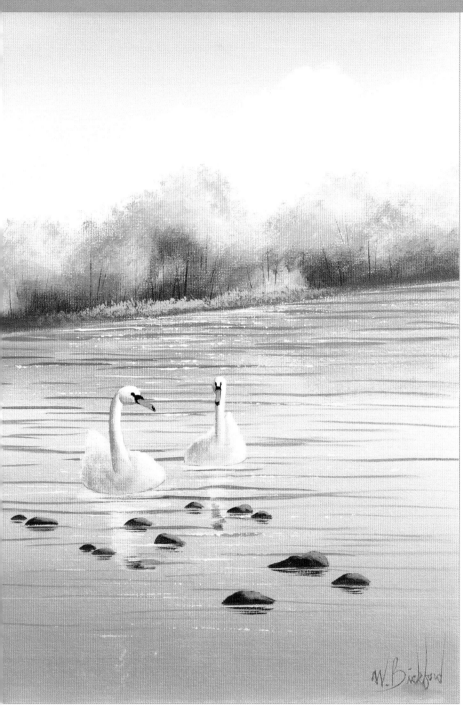

12 Add the Finishing Details

Scrutinize your work. Would it help to lighten or darken anything? Add more white to the clouds or swans? Add a little more color in the trees? Painting is about making adjustments, so don't be afraid to make improvements. Next time, try this scene with some pink in the sky and green trees! I added a few rocks in front of the swans. Follow the exercise on the facing page to add some to your painting.

Swan Duet
Acrylic on canvas panel board
16" × 12" (41cm × 30cm)

10 *Downy Woodpecker*

The downy woodpecker is the most common woodpecker in the eastern U.S. It closely resembles the hairy woodpecker, but is smaller in size. The two species are often confused with one another. Downy woodpeckers are acrobatic, and thus are fascinating to watch. They flit up and down tree trunks, often upside down, searching for insects in the nooks and crannies of the bark. They have a particular interest in the cedar trees in my front yard! Our cats Chloe and Tigger gather on the front porch to watch the birds at the feeders. They are captivated by their erratic and jittery movements.

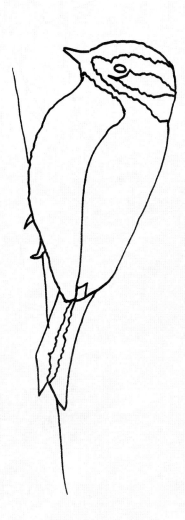

Woodpecker tracing actual size

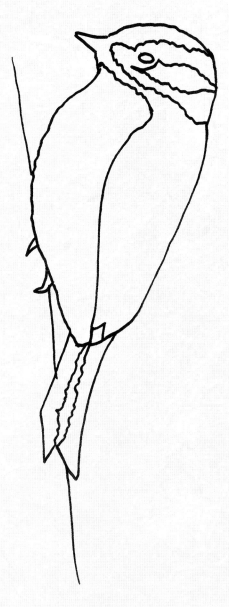

Woodpecker tracing enlarged size

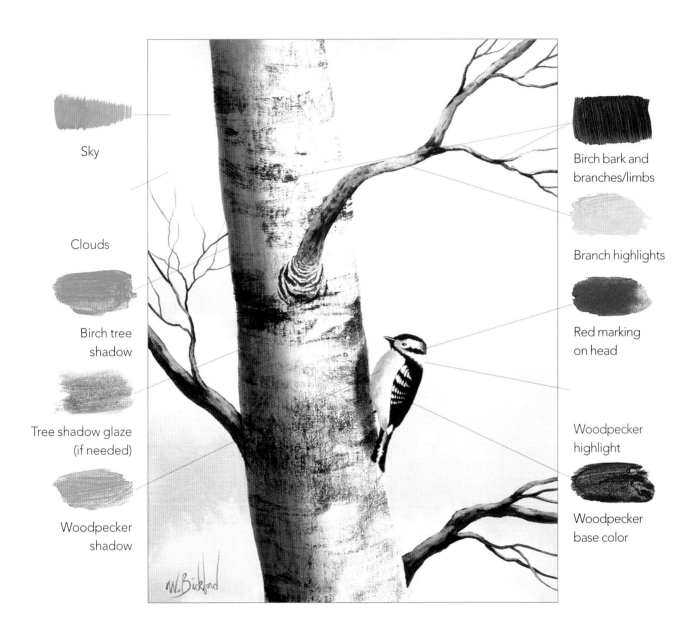

Sky

Clouds

Birch tree
shadow

Tree shadow glaze
(if needed)

Woodpecker
shadow

Birch bark and
branches/limbs

Branch highlights

Red marking
on head

Woodpecker
highlight

Woodpecker
base color

Color Mixtures

Sky, clouds, birch tree shadow, birch bark, limbs/
branches, branch highlights, tree shadow glaze (if
needed), woodpecker (body highlight, body shadow,
body basetone and red marking)

1 Begin the Background

Draw the outline of the tree trunk with your pencil. Unlike the previous projects, this one requires no horizon line. Notice the left-of-center placement of the tree on the canvas and that it leans slightly. A perfectly straight arrangement is unnatural and boring!

Dampen the sky areas on both of the outer sides of the tree with the mister bottle. Lay a coat of gesso on these areas using the wash brush. Apply an even distribution, but avoid the tree shape. Work up to the edges of the tree with the gesso then sweep the paint back out to achieve a smooth coat. Add a small amount of blue to the brush to obtain a suitable sky color. If you wish to gray it down slightly, add a speck of sienna. Since this is such a large area of paint, don't hesitate to add a drop or two of water to your brush to keep the brush from tacking up.

Paint the entire sky background with this blue value. You may find it easier to establish the edges of the tree then work outward. Brush direction is not critical, so focus on smoothly painting the entire area. Wipe your brush and use lighter pressure to fine-tune the blend. Don't worry about any small markings you may have smudged on the tree shape. They can be painted over later.

2 Render the Clouds

While this area is still damp, use the corner of the no. 3 fan and pure white to paint in a few fluffy clouds. Use small circular strokes to detail the tops of the clouds, while lightly blending away the bottom edges. Defined top edges and indistinct bottoms will anchor the clouds and yield a more realistic appearance. Let your painting dry fully before moving on. If the white paint begins to dry out, simply drybrush into the blue sky rather than adding water to your brush. This will keep the clouds nice and fluffy.

3 Place the Trunk's Shadows

In the finished painting on page 125, notice the underlying gray-blue shadow on the left side of the tree compared to the white color on the right side of the tree. This shading gives a three-dimensional roundness to the trunk. Use the no. 10 bright and white to paint the right two-thirds of the tree. Use long, vertical strokes.

Working quickly, mix white, some blue and a touch each of red and sienna to create a gray-blue-violet shadow tone. Turn the bright brush vertically to establish the crisp left edge of the tree. Repeat this a few times to form a line of shadow, then turn the brush bristles horizontally and gradually work the mixture toward the white highlighted side of the trunk. Use lighter pressure and vertical strokes to mingle the colors and to achieve a gradual transition from dark to light. Let this stage dry.

4 Render the Birch Bark

Mix the dark bark color, a distinctive characteristic of birches, with mostly blue, some sienna and a touch of red. This mixture will also be used for the branches and woodpecker, so mix an ample amount. Use the no. 10 bright and drag the flat side of the bristles through the paint. Avoid getting paint on the tip because you are only painting with the sides of the brush. The idea is to skim the brush across the rough weave of the canvas to avoid filling in the tooth of the canvas too solidly. If you do get too much black mixture on the birch trunk, wait until everything dries and touch up the darkest areas with a dab of white on the brush. Dab and randomly drag your brush, overlapping some strokes to achieve random bark texture instead of only square brush shapes. You may find it helpful to tilt the brush now and then to avoid identical strokes. Let the canvas dry before moving to the next step.

Turn the Canvas for a Better Angle

Turn the canvas on its side or place it on your lap if you are having a hard time pulling the brush sideways. Use whichever angle works best for you.

Birch Bark Technique

Drag the flat side of the bristles through paint. Avoid getting any on the tip because you will only be painting with the sides of the brush. Hold the brush with an overhand grip (the top of the wrist should be on top of the handle) and flush the flat side of the bristles against the canvas. To create the birch bark texture, lightly drag the brush across the tree trunk creating a rough, dry-brushed appearance. If the paint does not release from the brush, simply add a few drops of water to the mixture.

5 Add the Limbs

To paint the limbs, use the mixture from step 4 with a no. 2 round for the larger limbs and a script liner for the twiggy branches. Thin the paint with a little water to improve its flow and pull out the limbs beginning at the trunk. Strive for a varying thickness of the limbs and branches (for tips on painting the thinner limbs see the "Simple Leafless Tree" exercise on page 52).

Softly blend the large limb on the front of the trunk with a light dry-brush technique, making it appear connected and attached to the trunk. Don't blend the two limbs that come out of the sides of the tree. Instead, paint a hard, crisp edge with the chiseled edge of the no. 10 bright to give them the appearance that they're growing out of the rounded backside of the trunk.

6 Create the Growth Collar

On the front tree branch, use the liner with the thinned black branch mixture from step 5 to paint the concentric rings, also known as the *growth collar*, where the limb attaches. Bring the brush to a fine point with the paint and squiggle in the lines like rough circles surrounding a bull's-eye.

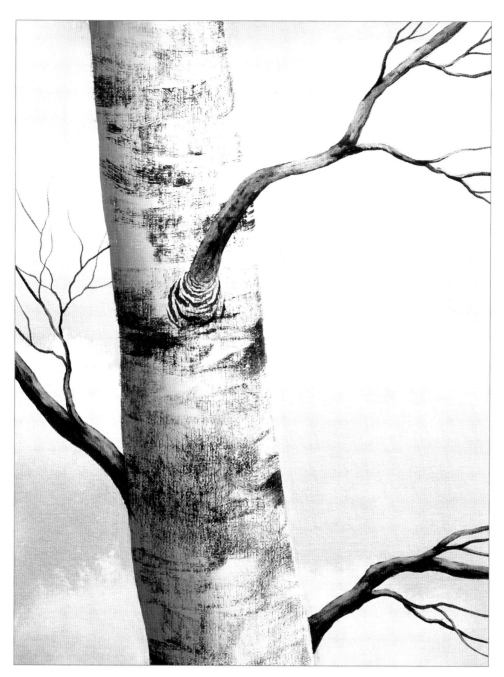

7 Establish the Branch Highlights

To highlight the limbs and branches, create a grayish mixture by adding a bit of white to some of the black mixture from the previous steps. With the no. 2 round, dab this lighter value onto the tops of these areas of the larger limbs. Thin the mixture and use the script liner to add highlights to the thinner limbs. Don't paint the highlights too solidly, a hit-or-miss look is desirable to mimic the way sunlight bounces off objects in nature. Similarly, a rougher texture will give the branches a realistic look, so don't try to smooth everything out completely. Look at the overall tree form and branches and add more branches and highlights to your liking.

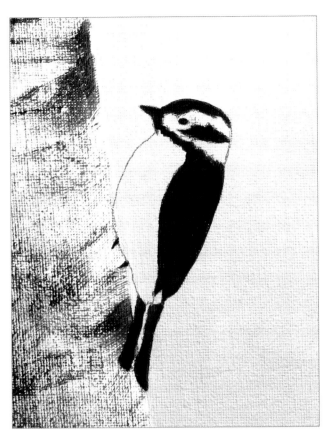

8 Transfer and Block In the Woodpecker

When your painting is completely dry, transfer the woodpecker sketch, making sure that the claws contact the trunk. With the no. 2 round and the black color from step 4, paint in all of the dark sections of the bird. Block in the wing, head and tail area completely with one or two coats of the black mixture. Thin the mixture with a drop or two of water and paint the claws with the liner.

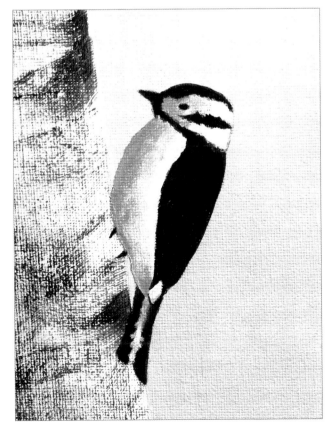

9 Block In the Light Tones and Shadows

When the black sections are dry, use white and a no. 2 round to carefully fill in all of the white sections of the head, belly and tail. For the body shadows, create a new gray-violet mixture with white, blue and a touch of red. Using the same brush, blend this value into the white for a gradual transition from dark to light. This suggests the roundness of the woodpecker's body, face and belly.

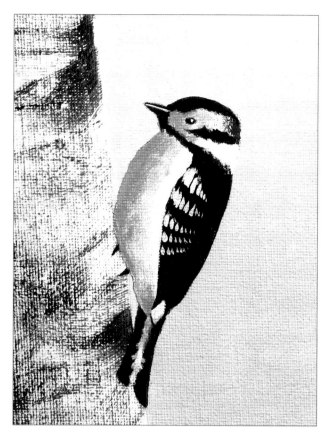

10 Paint the Wing and Facial Markings

Use the script liner to paint the white wing markings. Notice that they decrease in size as they wrap around the bird's back. Don't forget the small, white diamond shape at the bottom tip of the wing. Add a tiny dot of white to the center of the eye, and a sliver of highlight along the top of the beak.

Rinse the brush clean, and touch in a small amount of pure red on the back of the head. Wipe the brush and softly blend this spot into the white of the woodpecker's face. Check the finished painting at right for guidance. By now, your woodpecker should be looking pretty good!

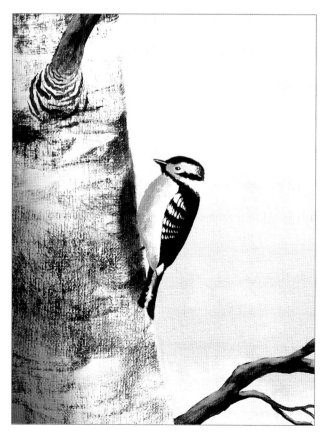

11 Add the Cast Shadow

Add a cast shadow to connect the bird to the tree. Using a damp no. 2 round, create a purplish gray mixture with blue, a touch of sienna and a speck of red. Do not use any white in the mixture to keep the color from appearing opaque and chalky. Shadows should always appear transparent. From top to bottom, brush in a shadow shape with gentle vertical strokes to reflect the size and length of the bird.

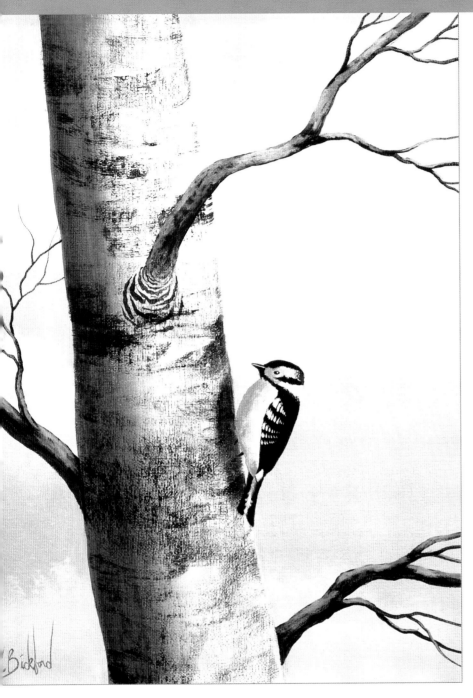

12 Add the Finishing Details

To create contrast, add in a final cast shadow to the left side of the main tree trunk using the shadow value from step 11. Load the no. 10 bright bristles to a chiseled edge and pull the brush vertically down the edge, all the way from the top of the trunk to the bottom. Wipe the brush with a damp paper towel and sweep long, vertical strokes up and down the dark edge to blend the shadow into the trunk, creating a soft transition. That should do it! What do you think? Does your bird look real enough to fly away? Remember, no painting is finished until any needed adjustments are made. Check your contrasts and don't be afraid to lighten and darken as needed.

Downy Woodpecker
Acrylic on canvas panel board
16" × 12" (41cm × 30cm)

Conclusion

So, there you have it. My wish is that this book has helped to instruct, inspire and motivate you to create your own works of art. Please remember that painting is just a form of self-expression and is not a contest. Do it for *you* and no one else. Art is a journey to an unknown destination and that is what makes it so worthwhile and exciting.

Take my ideas and techniques and tweak, twist and mold them to fit your style and way of thinking. Ultimately, your paintings will reflect your own personality.

Wilson Bickford

Loons on the Lake
Acrylic on canvas panel board
12" × 16" (30cm × 41cm)

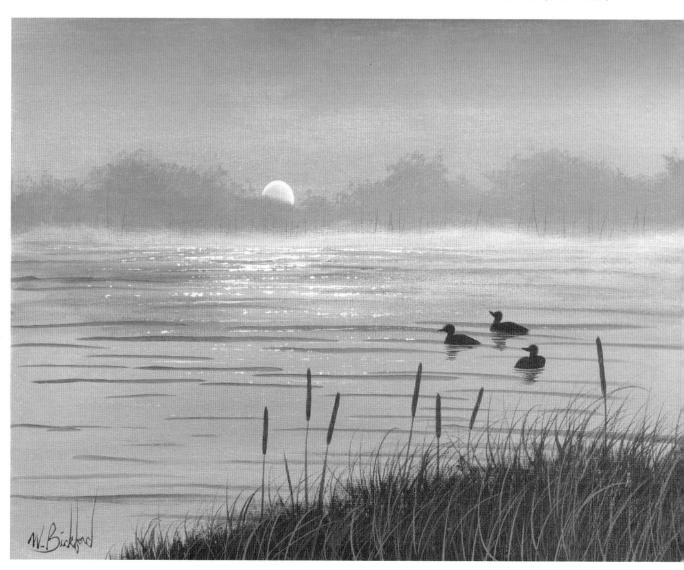

Index

The BEST in Acrylic Instruction
is from North Light Books!

Painting More Animal Friends gives you easy techniques for painting realistic animals with 21 paint-along acrylic projects! Jeanne Filler Scott follows up her popular first book with more expert instruction on painting your favorite furry friends. Includes detailed demos on chipmunks, deer, elephants, tigers, exotic birds and an entire chapter on adorable baby animals. This book is perfect for animal lovers of all skill levels, even complete beginners.

ISBN 13: 978-1-60061-034-9
ISBN 10: 1-60061-034-X
Paperback, 128 pages, #Z1377

Jacqueline Penney has lived near and been inspired by the water for over 30 years. In *Painting Seaside Scenes with Acrylics* she shares her favorite techniques and expert tricks for capturing the atmosphere and romance of the ocean in acrylics. Includes 16 gorgeous projects and step-by-step instruction for painting a wide range of seascape elements including sand dunes, driftwood, sailboats, fishing shacks, pebbly beaches, ocean spray and many realistic textures.

ISBN 13: 978-1-60061-059-2
ISBN 10: 1-60061-059-5
Paperback, 128 pages, #Z1751

Let your paintbrush and imagination take you on a stroll through lovely landscapes. Ten complete step-by-steps and ten mini-demonstrations show you how to paint romantic scenes brimming with blooming flowers. Full-color photos, detailed instructions, traceable patterns, color swatches and detailed materials lists make these projects easy for painters of any skill level. You'll find everything you need to paint your garden getaway.

ISBN 13: 978-1-60061-101-8
ISBN 10: 1-60061-101-X
Paperback, 128 pages, #Z2037

These and other fine North Light books are available at your local art & craft retailer, bookstore or online supplier or visit our website at www.artistsnetwork.com.